The Beginner's Guide to

watercolor

Master Essential Skills and Techniques through Guided Exercises and Projects

Jovy Merryl

founder of Aquarryl Studio

PAGE STREET
PUBLISHING CO.

PAGE STREET
PUBLISHING CO.

First published in 2021 by
Page Street Publishing Co.
27 Congress Street, Suite 105
Salem, MA 01970
www.pagestreetpublishing.com

Distributed by Macmillan, sales in Canada by The Canadian Manda Group.

25 24 23 22 21 1 2 3 4 5

ISBN-13: 978-1-64567-354-5
ISBN-10: 1-64567-354-5

Library of Congress Control Number: 2021931350

Cover and book design by Julia Tyler for Page Street Publishing Co.
Art and illustrations by Jovy Merryl
Photography by Denise Camille Que

Printed and bound in China

The Beginner's Guide to

watercolor

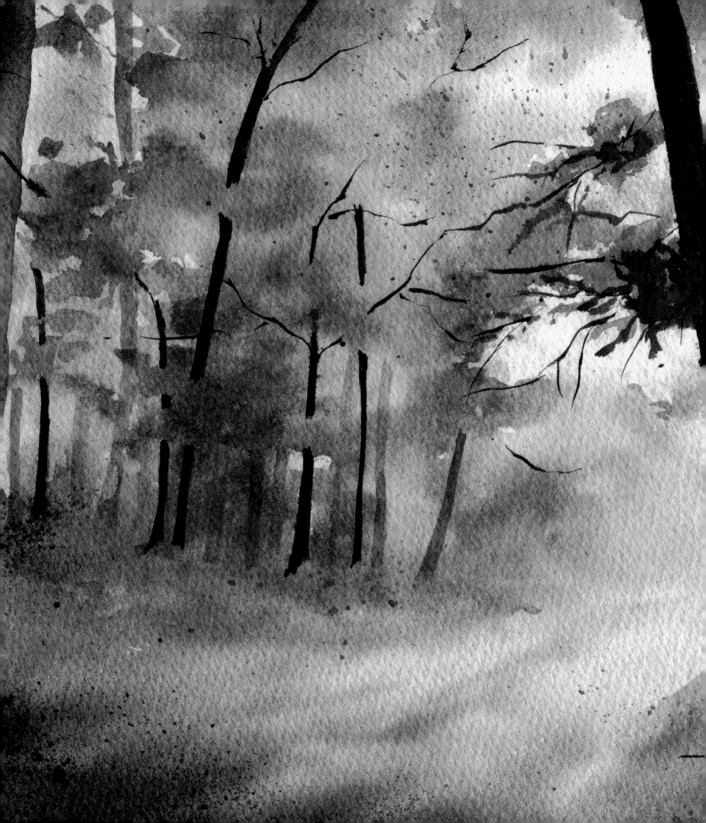

TO MAMA GLORIA

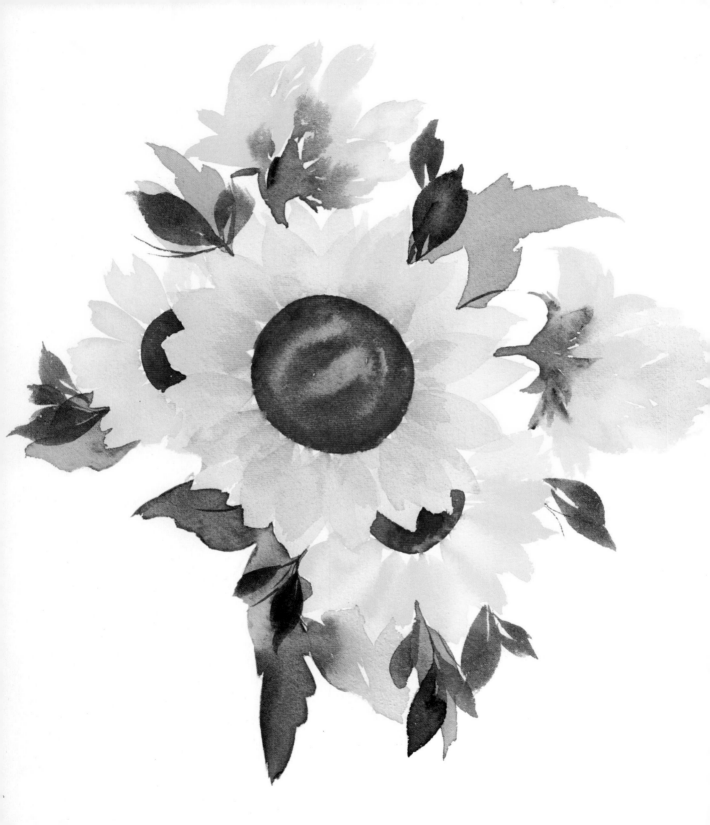

Contents

Introduction

One normal day at work, a colleague suggested that I try watercolor painting. I was ready to say "I think I'll pass"—I had no painting experience, no prior knowledge of or exposure to any painting medium, and I felt like it was too late for me to be artsy. I played sports growing up. My first love was volleyball, and I skipped classes for that (apologies to my parents). Then I dedicated my entire early adult life to building a career and business.

I had hundreds of reasons to say no that day. But you know what? I decided to accept the challenge.

Month after month, I painted almost every day and every night. I sat down and took out supplies that I had no idea how to use at all. I just painted and wished for happy mistakes and "aha" moments! During those times, it never crossed my mind to watch tutorials, read books or ask around for some help. It was just me, my patience and my watercolor supplies. It was enjoyable, it was peaceful and it was a therapy for me. Watercolor is beautiful, with a certain degree of wildness. As time went by, I became so passionate about it that I started reading articles and books that often referred to watercolor as stubborn, uncontrollable and the hardest medium of them all. All of those descriptions are true to some degree, but watercolor is a friend for me. It took a while, but once the friendship developed, a whole new world opened up for me.

This medium has given me so many opportunities I never thought could be possible. I became an ambassador of the White Night of Nevskaya Palitra, became one of the first Certified Silver Brush Educators in Asia, conducted in-person and private workshops and collaborated with respected brands all over the world. More importantly, though, this medium has given me a new perspective in life, countless hours of self-care and a medium to communicate.

As a self-taught watercolorist, I enjoyed the privilege of getting to know this medium through first-hand experience in the early days of my creative journey. I learned almost everything the hard way, so trust me when I say I know the struggles, I know the frustrations and I'm happy to share tips to help you overcome these challenges.

In this book, we are going to break down our watercolor journey into five simple goals. These goals will help you align your focus, sustain your momentum and measure your progress. Step by step, I will help you gain confidence by giving you all the foundational knowledge you need to work toward each goal. We will start with the simplest but most important step: familiarizing yourself with the right materials. You will enjoy the process of learning more if you are comfortable with your tools. Then we will explore how to choose harmonious colors, how to blend the right amount of water and paint and how to apply the right brush techniques for painting florals and other landscape elements. By the end of the book, you will have learned how to use all these techniques and more, as well as how to start telling your very own story through watercolor painting.

There's a total of 25 projects included to help you practice the essentials. They have been carefully curated to gradually build your skills, so it's best to work on them in order—especially if you're new to watercolor painting.

The process of learning and trying things for the first time is the hardest part, but it is also the most enjoyable. It is normal to get frustrated along the way, but don't give up! Try to laugh at your mistakes and remember that you are on your own journey. Watercolor painting is fun, therapeutic and so much more. I can't wait for you to get started!

LOOSE WATERCOLOR

Loose watercolor is a conscious artistic decision to paint a subject based on its essence. It is a visual expression of shapes, structure, light, distance and atmosphere that is suggestive rather than literal. Loose watercolor is free from an obsession over details.

The most important thing to remember when painting with this book is that a realistic painting is not the desired end result. You will hone your painting skills one goal at a time while celebrating imperfection and the rawness of nature as your subject. The techniques I am about to impart are not intended to replicate any painting subject in its realistic form; rather, the intention is to give you the foundational knowledge to express yourself through watercolor painting.

Jody Merryl

Getting to Know the Tools

When I made the decision to get serious about advancing my painting skills, I started investing in artist-grade supplies. It was an overwhelming process, as there were many good choices, and it was hard to decide what to pick. I literally tried all the papers and paints that were available at the local art store—and there were even more options from online stores. It was not an economically wise process, and it consumed a lot of time, but when I found the proper materials, painting became less frustrating and much more enjoyable.

In this section, I will share suggested tools and supplies that will help you get started with watercolor painting with fewer frustrations and more joy.

WATERCOLOR PAPERS

Watercolor paper is arguably the most important tool in watercolor painting. One can spend a lot of time learning new techniques only to realize that their paper won't let them carry out the procedures, and that is a hard lesson learned.

Watercolor paper comes in three different surface textures:

Hot press has a smooth surface and is not as absorbent as the next two. This texture is ideal for detailed painting.

Cold press is the most commonly used texture and is beginner-friendly.

Rough paper has the roughest surface texture and is sometimes described as having a heavy, high or prominent "tooth."

The weight of the paper is important to consider based on the amount of water and the techniques that will be applied. Lightweight papers may buckle and wrinkle, which makes them difficult to use for watercolor painting.

Good-quality watercolor paper has a protective coat of sizing. Sizing is a substance that is added to paper during the manufacturing process to give it strength and protect it from damage and dirt. It coats the fibers to help them resist paint and water. However, sizing is water-soluble, so stretching or soaking the paper will dissolve much of the sizing and make it more absorbent, resulting in the watercolor pigment working its way down into the paper fibers. Washes of pigment will dry lighter as the pigment sinks deeper into the paper.

I always recommend professional-quality or artist-grade paper that will not yellow as it ages, is sufficiently strong enough to withstand severe techniques and has the right degree of absorbency for the kind of painting the artist wants to perform. My choice is 140lb (300gsm), 100% cotton rag, cold press or rough. My personal favorites are The Collection by Hahnemühle and Arches® by Canson. For a more affordable option to start out with, I recommend Baohong.

PIGMENTS

Watercolor paints are made from either natural pigment found in nature or from synthetic pigments that have been finely ground and bound together with a water-based "gum." The paints are most commonly packaged in pans and tubes, but they are also available in concentrated liquids, cakes, sheets and sticks. Professional-grade paints, as opposed to cheaper student-grade ones, are more refined, more vibrant and more transparent. Transparency is a key characteristic of watercolor. Transparent colors give viewers an impression of glow and luminosity, as they allow a degree of light to pass through the colors and bounce off the white paper.

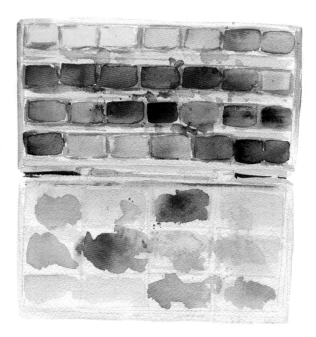

After years of painting, I decided to stick to one brand as my main palette. White Nights of Nevskaya Palitra is highly pigmented, vibrant and reasonably priced.

The colors from White Nights that I normally use for landscapes are (from left to right) Aureolin, Golden Deep, Cadmium Orange, Titan Red, Cobalt Blue, Ultramarine, Sap Green, Quinacridone Rose and Burnt Sienna.

For florals I use (from left to right) Aureolin, Golden Deep, Quinacridone Rose, Cobalt Turquoise, Sap Green, Olive Green and Raw Sienna.

For seascapes I use (from left to right) Turquoise Blue, Azure Blue, Bright Blue and Emerald Green.

Another palette I normally use for shadow, signature or for other mixes is (from left to right) Indanthrene Blue, Indigo, Payne's Gray, Ruby and Chromium Oxide.

Other brands of watercolor paints that I enjoy are Mijello™, M. Graham, Turner Watercolors and Daniel Smith.

BRUSHES

Brushes are our magic wands in the world of painting, as they help us execute our ideas. That is why having the right brushes is very important! Using quality brushes will allow you to load a generous amount of water and pigment and release it in a steady flow, creating both thin lines and gestural marks. Good brushes can also withstand "abuse" or frequent use.

The brushes that I use most often are the Black Velvet line and Silver Silk 88 from Silver Brush Limited®.

Knowing the capabilities of your brushes will help you tremendously as you paint. Each brush creates different watercolor effects, so you should select which one to use according to how you want to handle a particular area or subject of your painting.

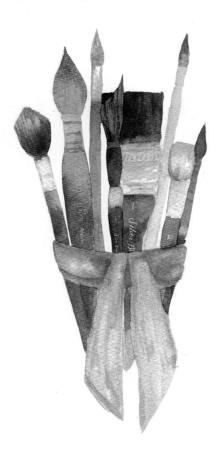

ROUND BRUSH

Round brushes are the most versatile and most commonly used in watercolor painting. They have a pointy tip and, depending on their size, can be used for delicate work or for laying down washes.

FLAT BRUSH

The flat, or one-stroke, brush is good for toning paper, laying a wash and making thick linear strokes.

SCRIPT AND RIGGER BRUSHES

Script and rigger brushes have extra-long bristles. Script brushes have fuller bodies and pointier tips than riggers, but both brushes make marks that are consistent in width.

WASH BRUSHES

Flat wash, hake and mop brushes are similar to flat brushes, just much wider. I use these brushes to apply lots of water and pigment at once.

ANATOMY OF A BRUSH

A paintbrush consists of three major parts: the bristles, the ferrule and the handle.

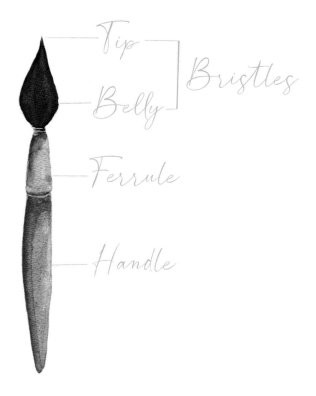

BRISTLES

Sometimes referred to as the head of the brush, the bristles are the part that holds the paint. The top of the bristles is called the tip, and the fattest part of the bristles is called the belly. Bristles are made from natural hair, synthetic fibers or a combination of both. *Natural* varieties are made from some sort of animal hair, such as hog or badger. *Synthetic* varieties are often made from nylon, polyester or a combination of both. The quality of the bristles determines the cost of the brush.

FERRULE

The ferrule is the crimped metal piece that secures the bristles in place and attaches them to the brush handle. Better-quality brushes have a brass or copper alloy ferrule. Cheaper brushes often use weak ferrules and adhesives that allow the bristles to shed and the ferrule to detach from the handle. The quality of the ferrule will affect the quality and longevity of use of the entire brush.

HANDLE

Handles can be made of wood, acrylic or bone. Most are made of hardwoods like beech. They can either be short or long. Watercolor brushes are normally made with short handles.

OTHER MATERIALS

Aside from papers, brushes and paints, which are the main supplies needed for watercolor painting, you will always need a clean cloth or tissue to squeeze out excess paints and water from your brush and to keep your paper clean from unwanted pigment stains.

You will also need a clean mixing palatte, a jar or two of clean water, masking tape, a pencil and an eraser to make the process easier and more exciting.

Exploring Color Harmony

In watercolor painting, harmony is something that is pleasing to the eye. It creates a sense of balance and comfort that captivates the viewer. Conversely, a lack of color harmony will make a painting less pleasing. The moment I understood how significant color harmony is in painting, my processes and presentations changed dramatically.

Putting together harmonious color combinations begins with understanding how we see colors and the relationships of each hue to one another. A good way to recognize color relationships is to study the color wheel.

Color Wheel

The primary colors are red, yellow and blue. These three colors are pure, can't be created by mixing other colors and usually contain only one pigment. Mixing equal parts of these three colors will produce black, but mixing two at a time will produce secondary colors.

The secondary colors are green, orange and violet. They all result from mixing two primary colors.

Tertiary colors are mixtures of a primary and a secondary color. For example, you can create red-orange when you mix red and orange.

Pre-mixed tertiary paint colors can easily get you into a huge muddy mess of clashing colors. Unless you totally understand how pigments will react to each other, it's best to stick with pure primary colors and pure secondary colors when you're just starting out.

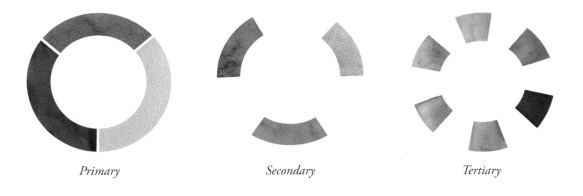

Primary *Secondary* *Tertiary*

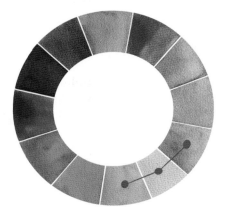

FORMULAS FOR COLOR HARMONY

Analogous colors are the easiest to identify. They are any three colors that are side by side on the color wheel. Pick any color at any point on the wheel. Then, note any two colors directly to the left or right of it, and that's it! Usually, one of the three colors will be a primary or secondary color. The example in the picture shows the analogous colors of yellow, yellow-green and yellow-orange. Analogous color schemes are usually found in elements of nature, such as succulents and autumn leaves.

Complementary colors are like yin and yang. On the color wheel, they are directly opposite each other. A few examples are red and green and red-purple and yellow-green. Usually, the pairing consists of one warm color and one cool color.

When you place two complementary colors next to each another, the high contrast between them creates a vibrant look. Both colors will appear brighter and grab a viewer's attention. However, if you mix the two complementary colors in equal parts, you will get a warm-toned dark brown or gray.

Split complementary colors consist of a primary color and two analogous colors to its complement. In the sample provided, blue is matched up with yellow-orange and orange-red instead of orange, which is the direct complement to blue.

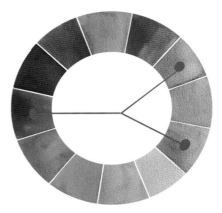

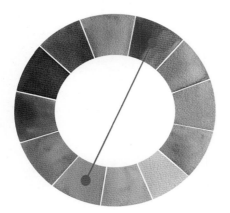

*Triadic color*s are any three colors that are evenly spaced around the color wheel.

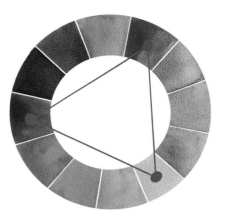

MODERN ABSTRACT

The goal of our first project is to let you warm up with colors and water to eliminate the fear of fusing watercolor on a blank sheet of white paper. Trust me, I know how scary it is and I know how fear can ruin the spark of creativity you have in you. Always keep in mind that there is no right or wrong way to do this, but it's very important that you let loose, start picking up colors and let your brush dance. Turn on your favorite music, take three deep breaths and let's start having fun! As the cliché goes, "All journeys begin with a single step." That jump-start step is embracing that you have to put something onto that blank paper to make your imagination come alive.

MATERIALS

Masking or painter's tape

140lb (300gsm), 100% cotton rag, cold-pressed watercolor paper

Painting board

Flat brush (page 12)

COLOR PALETTE

Quinacridone Rose, Indigo and English Red

STEP 1: PREPARATION

Prepare the materials on your painting table. Using masking or painter's tape, secure your sheet of watercolor paper to a board. This is to prevent the paper from buckling or curling. You can skip this step if you're using a block of watercolor paper.

Heads up! We are going to paint fast and quick, so there's no time for second thoughts. You're going to make quick strokes and then change the color loaded in your brush.

STEP 2: THREE BIG STROKES

Load your flat brush with a watery mixture of Quinacridone Rose. From left to right, paint one big stroke. Immediately rinse your brush to remove the pigment. While Quinacridone Rose is still wet, quickly load your brush with a watery mixture of Indigo and make another big stroke just below the Quinacridone Rose, slightly making contact to encourage blending between the two colors. While Indigo is still wet, rinse your brush and load it with a watery mixture of English Red. As with the first two colors, paint a big stroke below Indigo. Let all the paint dry.

STEP 3: FINAL STEP

Load your brush with a slightly concentrated mixture (page 20) of Indigo, and paint a stroke from left to right below the English Red, keeping some distance between the colors. While the concentrated Indigo on the paper is still wet, rinse your brush and, with just water on it, paint a quick stroke below and above the concentrated Indigo. Let these strokes brush against the concentrated Indigo.

While the three strokes of Indigo are still wet, load your flat brush with a slightly concentrated mixture of English Red and paint another big stroke below the Indigo. Tilt your board or your block of paper to encourage the colors to flow into each other while they're still wet.

Do not worry about the shape—the idea is to let loose, take the first step, accept the imperfection and enjoy the process!

Understanding Water-to-Paint Ratio

Now that you are equipped with knowledge about the basic tools of the trade and color harmony, you are ready for a more daring and thrilling adventure. Water is the most important aspect of watercolor painting, and it took me ages to pay close attention to it. I won't let you make the same mistake, which is why we will focus on understanding water-to-paint ratio in this chapter.

Tea-to-Butter Analogy

Understanding how to mix the right amounts of water and pigment is crucial because it determines the darkness and lightness of a painting. A higher water-to-paint ratio results in a lighter value; a lower water-to-paint ratio results in a darker value.

Learning the "Tea-to-Butter" analogy for paint consistency was a game changer for me. I learned about it at an in-person workshop years ago, and it has been one of my foundations in watercolor painting ever since. For this reason, I encourage you to pick up your brush and a color of your choice, and let me guide you as you practice Tea-to-Butter watercolor ratios.

In the chart below I used Indigo by White Nights.

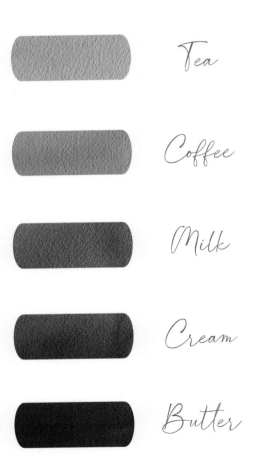

TEA

This consistency produces the lightest colors. It's mostly water with just enough pigment to see the color. When mixing a puddle on your palette, the paint should flow easily. Think of how watery a good steeped tea is. Tea ratios can be used for washes.

COFFEE

Just as coffee is darker and has a thicker consistency than tea, there should be more pigment but still enough water to flow on your mixing palette. Coffee ratios can be used for washes as well.

MILK

Think about how milk has more body to it than coffee does. This mixture has even more pigment than coffee. The paint doesn't flow as easily on the palette now.

CREAM

This consistency has more pigment than milk. In fact, there is very little water at all. It is thick and creamy and should not flow on your palette at all. This is where most of the darkest darks should come from.

BUTTER

This is straight from the tube with very little water—just enough to make it flow.

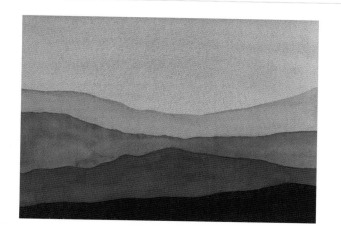

GRADIENT MOUNTAIN

In general, when objects are farther away from us, colors get duller and the tone shifts toward blue. The details of the objects disappear as well. As objects recede, they lighten in value and their background contrast disappears. Gradient Mountain is the perfect project to practice Tea-to-Butter ratios. You will focus on paint consistency in this project and apply what you've learned in the previous lessons. Let's start, shall we?

MATERIALS

Masking or painter's tape

140lb (300gsm), 100% cotton rag, cold-pressed watercolor paper

Painting board

Pencil and eraser

Flat or hake brush (page 12)

Round brush (page 12)

COLOR PALETTE

Ultramarine and Indigo

STEP 1: SKETCH

Prepare the materials on your painting table. Using masking or painter's tape, secure your sheet of watercolor paper to a board. This is to prevent the paper from buckling or curling. You can skip this step if you're using a block of watercolor paper.

With the paper in landscape orientation, lightly sketch the outline of the mountain peaks. Create four layers of mountain ranges in the middle third section of your paper.

STEP 2: SKY AND BACKGROUND

Prepare a tea-like consistency (page 20) of Ultramarine. Make sure you prepare enough to cover the whole paper. Set aside while you wet the paper using a flat or hake brush.

Using tea-like Ultramarine and a round brush, paint the paper from top to bottom. Let it dry.

STEP 3: MOST DISTANT MOUNTAIN

Make sure the paper is completely dry before you proceed with this step.

Prepare a coffee-like consistency (page 20) of Ultramarine. Make sure you prepare enough to cover the most distant mountain. Now load your round brush and paint the most distant mountain, using the sketch as a guide. Let it dry.

STEP 4: MIDDLE MOUNTAIN

Prepare a milk-like consistency (page 20) of Ultramarine. Make sure you prepare enough to cover the middle mountain. Once the most distant mountain is completely dry, load your round brush and paint the middle mountain. Let it dry.

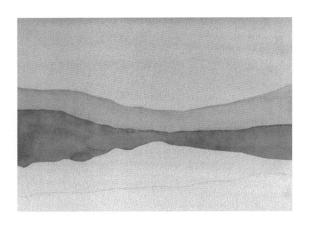

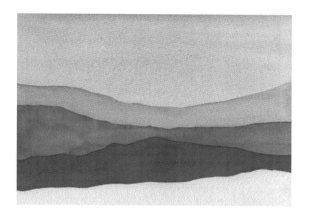

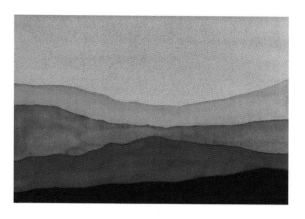

STEP 5: FIRST MOUNTAIN

Prepare a cream-like consistency (page 20) of Ultramarine. Make sure you prepare enough to cover the first mountain. Once the middle mountain is completely dry, load your round brush and paint the first mountain. Let it dry.

STEP 6: FOREGROUND MOUNTAIN

Prepare a cream-like consistency of Ultramarine with a hint of Indigo. Make sure you prepare enough to cover the foreground mountain. Once the first mountain is completely dry, load your round brush and paint the foreground mountain. Let it dry. After your painting is completely dry, carefully remove the tape on the sides and sign your masterpiece.

Learning Brushmarks

Different brushes can be used in several ways, depending on the style or approach preferred by the artist. A brush can be used to apply washes evenly within prescribed areas or create expressive brushmarks. With time, practice and dedication, every artist develops a unique brushmarking aesthetic.

When I first started painting years ago, I was stuck in a rut of brushmarking florals for months. I kept painting on huge sheets of watercolor paper to practice, but my progress was nothing like what I envisioned. Frustrated, I channeled my inner Hermione Granger and pretended it was a mystery to solve. With a lot of patience and practice, I was successful in unlocking the techniques I needed to make my brushmarks more efficiently.

In this chapter, we will discuss and practice the techniques that helped me improve my brushmarks. We will start with the suggested way to hold a brush, then proceed to the effects of applying different amounts of pressure and, lastly, the basic strokes I normally use when painting florals and trees. Now who's ready for some brush dancing?

How to Hold a Brush

There's no perfect or ideal way to hold a paintbrush. Different ways of holding a brush produce different effects.

There are three main ways to hold a brush:

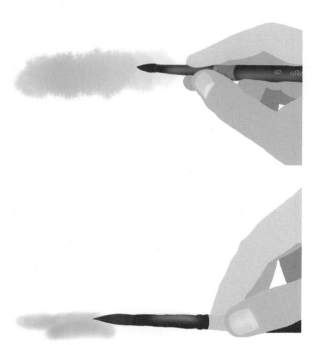

PENCIL OR CLASSIC GRIP

Think about handling a brush like a pencil using your thumb, index and middle fingers. This is helpful for more controlled strokes. I often use this grip when painting on small-sized paper and for detailed work.

PINCH GRIP

Pinch your brush between your thumb and index finger. Hold it like you're picking up a pen on your table. This grip doesn't have much control, but it can be of great help when dry brush painting.

BATON GRIP

Hold the brush at the end of the handle, away from the bristle, like an orchestra conductor's baton. This grip will give you a more expressive and looser stroke. I use it when I'm painting on a large canvas, especially when doing washes.

Applying Pressure

As a general rule, the more pressure you apply to the brush, the more paint will be transferred onto the paper, resulting in a thicker stroke. Ideally, daily practice will make your brushmarks look effortless, confident and authentic.

There are four different amounts of pressure I normally use when painting:

Feather pressure is the lightest pressure you can use to produce thin lines and detailing.

Light pressure allows the bristles of the brush to bend a little against the surface of the paper.

Semi-heavy pressure makes half of the bristles of the brush touch the surface of the paper.

Heavy pressure is much firmer and causes the full length of the bristles to touch the surface of the paper. It is commonly used to produce thicker strokes.

LET'S PRACTICE!

This exercise aims to introduce four different amounts of pressure to your muscle memory. We will be using a round brush (page 12) in this exercise. Once mastered, you can try these exercises using different sizes of round brushes.

PREPARATION

Use the following guidelines as you practice. Make horizontal, upward and downward motions as you paint lines with four different amounts of pressure.

Pick any color that you want to work with. If you have any paints that are not used often, now is a good time to put them to work. This is the one and only exercise where I can say that it's okay to use a student-grade paper or a cotton and cellulose blend paper because we only want to practice the amount of pressure we exert on our brushes.

Load your round brush with a milk-like consistency (page 20) of your chosen color. Using this consistency will make it easier to practice different amounts of pressure because it doesn't flow as easily. Now, let's train our painting muscles!

FEATHER PRESSURE

After loading your brush with a milk-like consistency of your chosen paint, hold your brush vertically with a pencil grip (page 26). The tip of the brush should barely touch the paper. You can stabilize your hand by touching your little finger to the paper, but the movement from left to right should be done by your arm and not your fingers holding the brush.

LIGHT PRESSURE

After loading your brush with paint, hold it at a 45-degree angle, still using a pencil grip. Let the tip of the brush bend slightly against the paper, and repeatedly practice this pressure with straight, downward and upward strokes.

SEMI-HEAVY

After loading your brush with paint, hold it at a 45-degree angle, still using a pencil grip. Practice straight, downward and upward strokes using semi-heavy pressure. Semi-heavy is similar to light pressure, only this time half of the brush head is against the paper.

HEAVY PRESSURE

After loading the brush with paint, hold it at a 45-degree angle, still using a pencil grip. Lay down the brush with its head full against the paper. Practice this pressure with straight, downward and upward strokes.

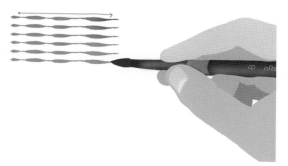

COMBINATION

Combine different pressures to attain thick and thin strokes. Practice combining different amounts of pressures in straight strokes. Repeat the whole exercise every day as you warm up before painting, until your muscles memorize the difference of each pressure.

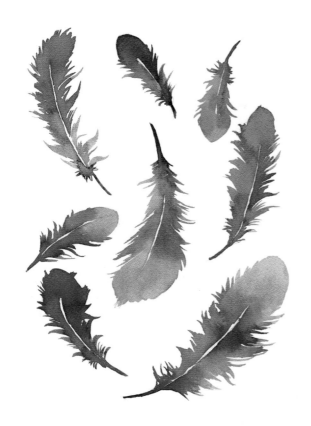

MAGIC FEATHERS PATTERN

There are a lot of ways to paint loose feathers. This soft-looking, delicate subject has been rightfully popular for a few years now. I have made a few of my own feather paintings, and the experience of painting them is enjoyable, which is why I want to share it with you.

Before we start, remember that it is totally normal not to get everything right on the first try, and that doesn't mean you are not good enough for this medium. It takes time, patience and one project after the other to see real improvement. This project will help you practice the different amounts of pressure you learned on pages 27 and 28, as well as preparing different water-to-paint ratios. Now get your painting table ready and let's continue!

MATERIALS

Masking or painter's tape

140lb (300gsm), 100% cotton rag, cold-pressed watercolor paper

Painting board

Pencil and eraser

Round brush (page 12)

COLOR PALETTE

Bright Blue, Quinacridone Rose and Indigo

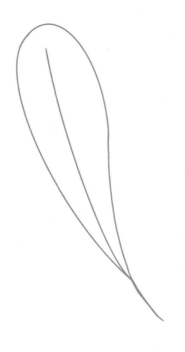

STEP 1: PREPARATION

Prepare the materials on your painting table. Using masking or painter's tape, secure your sheet of watercolor paper to a board. This is to prevent the paper from buckling or curling. You can skip this step if you're using a block of watercolor paper.

STEP 2: SKETCHING

Use a pencil to lightly draw the outline of the feather. If you can clearly imagine the shape of the feather, sketching is optional, but it is a useful guide when painting.

STEP 3: PREPARE YOUR PALETTE AND PAINT

Prepare milk-like and coffee-like consistencies (page 20) of both Bright Blue and Quinacridone Rose. Load your brush with a coffee-like consistency of Bright Blue and apply semi-heavy pressure (page 28) to make a stroke from the bottom of the feather going up. Along the right side of the feather, make strokes of different lengths, applying different amounts of pressure. Alternate using different consistencies of both Bright Blue and Quinacridone Rose.

Use the pencil sketch as a guide to form the shape of the feather. Let it dry.

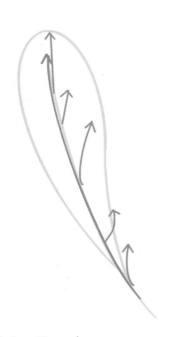

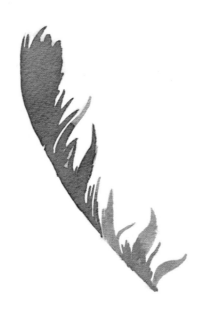

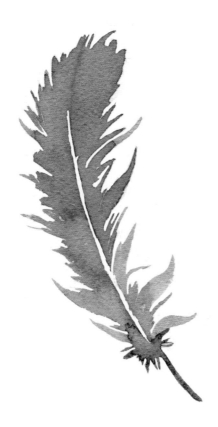

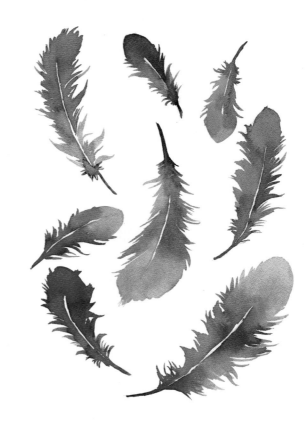

STEP 4: MIRRORING AND CLEANING

Repeat Step 3 to make the left side of the feather, being careful to leave a slim gap between the left side and right side. Then quickly prepare and load your brush with a coffee-like consistency of Indigo to make the bottom of the feather. Let it dry, then carefully erase the pencil lines.

STEP 5: MAKE A FEATHER PATTERN

Let's make a pattern by repeating Steps 1 to 4. You can use any colors that you want. Try to make smaller and bigger feathers. Rendering more variety is encouraged, but keep your primary focus on practicing different pressures. Doing feathers repeatedly will enhance your awareness of the effects of different pressures.

Brushstrokes

The last lesson in brushmarking is about making specific brushstrokes. Since you've already started developing the muscle memory you need to apply specific amounts of pressure, learning how to translate that into brushstrokes is going to be a lot easier. Brushstrokes fall into two general categories: push strokes and pull strokes. Some strokes may involve using just the tip of the bristles, while others may involve using the body or side of the bristles. In this chapter, we will discuss the basic and my most frequently used strokes in watercolor painting—the pointed stroke, curve stroke and droplet stroke.

POINTED STROKE

Create this stroke by slowly lifting the brush from the paper while changing the amount of pressure exerted. In the example, I shifted from semi-heavy pressure (page 28) to light pressure (page 28) as I reached the desired length of the stroke.

LET'S PRACTICE!

Load your brush with a milk-like consistency (page 20) of Olive Green or mix in equal portions of any blue and yellow from your palette to create a leafy color. Lay the brush down with semi-heavy pressure, then push it slowly away from you while changing to lighter pressure. Release the brush slowly, making sure that the tip of the brush made contact with the surface of the paper to give the stroke a pointy tip.

LEAFY WREATH

Wreaths were one of my favorite subjects when I was just starting my watercolor journey. They are simple and versatile. Wreaths are perfect borders for monograms or quotes, and you can paint them for greeting cards and invitations.

The repetitive leaf painting in this project will help you master the pointed stroke and the use of different amounts of pressure.

MATERIALS

Masking or painter's tape

140lb (300gsm), 100% cotton rag, cold-pressed watercolor paper

Painting board

Pencil and eraser

Round brush (page 12)

COLOR PALETTE

Chromium Oxide, Sap Green, Ruby and Ultramarine

STEP 1: PREPARATION

Prepare the materials on your painting table. Using masking or painter's tape, secure your sheet of watercolor paper to a board. This is to prevent the paper from buckling or curling. You can skip this step if you're using a block of watercolor paper.

STEP 2: SKETCHING

Draw a circle very lightly with a pencil. You will need this sketch as a guide to coordinate the elements so there will be a sense of balance and harmony. You don't have to draw all the elements on the wreath.

STEP 3: SLENDER LEAVES

The first element of the wreath is slender leaves. We are going to paint them on the upper left and lower right of the wreath. Load your round brush with a coffee-like consistency (page 20) of Chromium Oxide.

Start by painting the branch of the leaves using light pressure (page 28). Then use a combination of light and feather pressure (page 27) to paint the leaves.

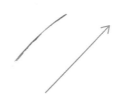

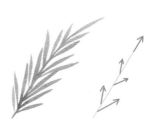

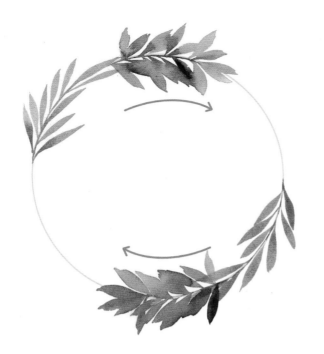

STEP 4: CLUSTERED POINTED LEAVES

Prepare a milk-like consistency (page 20) and a tea-like consistency (page 20) of Sap Green. Use both consistencies to paint clustered pointed leaves on the upper and lower parts of the wreath.

Pointed leaves are similar to slender leaves, only you will need to apply more pressure to make them than you did for the slender leaves. To start, load your brush with a milk-like consistency of Sap Green and use light pressure (page 28) to paint the branch of the leaves in an upward direction, then pull a pointed stroke (page 32) away from the bottom of the branch. While the first pointed stroke is still wet, load your brush with a tea-like consistency of Sap Green and paint another pointed stroke near the first one. Let the second pointed stroke brush against the first one. Do this step repeatedly on your way up toward the tip of the branch.

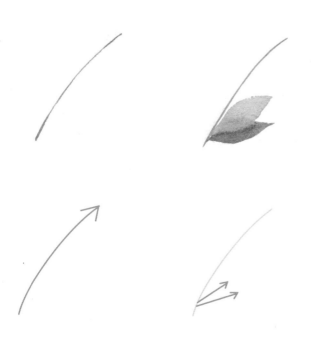

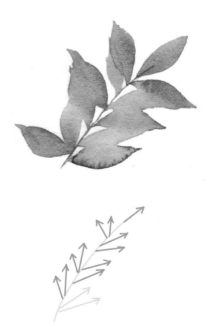

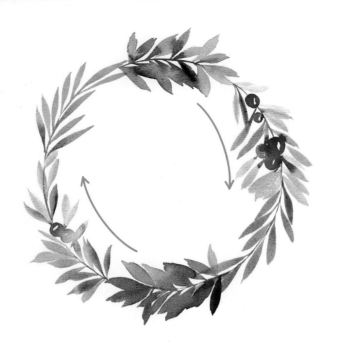

STEP 5: SLENDER LEAVES WITH RED BERRIES

Prepare milk-like and tea-like consistencies of Ruby and a coffee-like consistency of Chromium Oxide.

Load your brush with a milk-like consistency of Ruby and paint a circle shape for a berry. To suggest light, carefully leave a small white space inside the circle. Then load your brush with a tea-like consistency of Ruby and paint two smaller circles just beside the first one. Slightly brush these two against the first one.

While the berries are still wet, load your brush with a coffee-like consistency of Chromium Oxide. Use light pressure to paint a branch above and below the berries with upward strokes.

Because the berries are still wet, Chromium Oxide will spread or bleed into the berries. Don't worry—this effect adds interest. Continue to paint the slender leaves on the branch, then let it dry.

STEP 6: CLUSTERED POINTED LEAVES

To unify the rest of the composition and create an illusion of volume, paint clustered pointed leaves on the wreath overlapping other leaves. Alternate between using a milk-like consistency of Sap Green and a milk-like consistency of a mixture of Ultramarine and Sap Green.

For extra design, add small slender leaves using a milk-like consistency of Sap Green, and berries using a milk-like consistency of Ruby in random areas.

Let it dry.

CURVE STROKE

Imagine a comma punctuation mark or wide letter C—that's about what a curve stroke looks like. This kind of stroke is very useful in painting florals, fruits and other landscape elements.

LET'S PRACTICE!

Load your brush with a milk-like consistency (page 20) of Quinacridone Rose or any color of your choice. As you lay the brush down, start with semi-heavy pressure (page 28) and then shift to heavy pressure (page 28) while you pull the brush toward you along a curved path. Release the tip gradually.

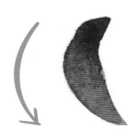

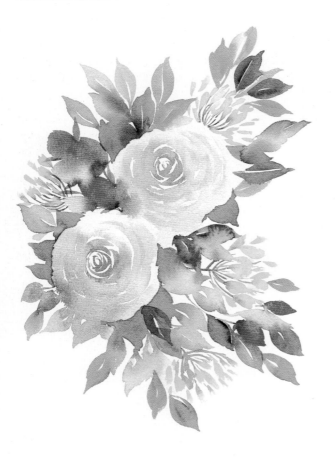

MELODY OF ROSES

Roses are timeless. For hundreds of years they have been used to symbolize love and passion. Their beauty knows no boundaries, and that is why roses are one of the most popular painting subjects. Loose watercolor roses are also the perfect subject to practice those curve strokes, which is the main goal of this project. Remember, the intention is not to paint realistic flowers. Developing muscle memory is what's most important, so just have fun practicing while painting.

MATERIALS

Masking or painter's tape

140lb (300gsm), 100% cotton rag, cold-pressed watercolor paper

Painting board

Round brush (page 12)

Pencil and eraser

COLOR PALETTE

Quinacridone Rose, Cadmium Red Light, Sap Green and Aureolin

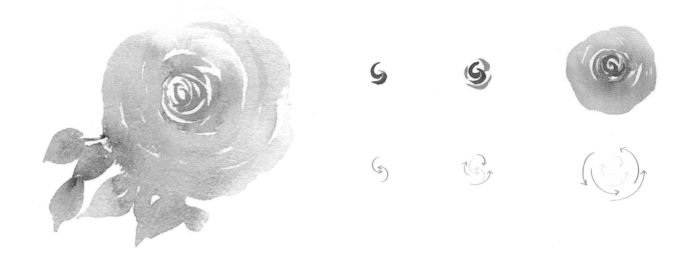

STEP 1: PREPARATION

Prepare the materials on your painting table. Using masking or painter's tape, secure your sheet of watercolor paper to a board. This is to prevent the paper from buckling or curling. You can skip this step if you're using a block of watercolor paper.

STEP 2: ROSE AND ROSEBUDS

Prepare a milk-like consistency (page 20) and a coffee-like consistency (page 20) of Quinacridone Rose for the roses, a milk-like consistency of Cadmium Red Light for the rose buds and a coffee-like consistency of Sap Green for the leaves.

To paint a rose, load your brush with a milk-like consistency of Quinacridone Rose. Start painting the center of the rose by making two small curve strokes (page 38). One curve stroke is similar to the letter C, and the other one is an inverted letter C. Paint these two strokes as if they are interlinked.

Continue making curve strokes around the center of the rose using the same consistency of the same color. Intentionally make some curve strokes thin, some thick, some short and some long. The general idea is to make them all a little different since petals are not perfectly even. The center curves should remain the smallest.

Load your brush with a coffee-like consistency of Quinacridone Rose while the inner curve strokes are still wet. Slowly paint bigger curve strokes around the smaller ones. While doing so, lightly brush the diluted curves against the more concentrated curves (inner strokes). Allow some gaps in between strokes so that it won't turn into a blob.

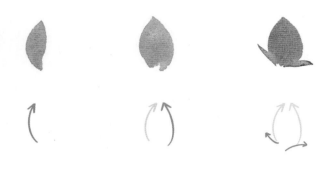

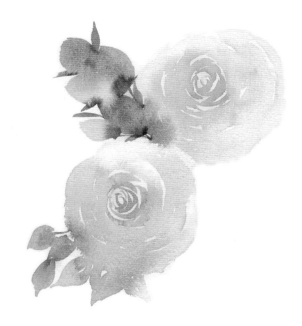

Once the roses are all dried, load your brush with a coffee-like consistency of Quinacridone Rose and paint thinner curve strokes on the top of the petals. Place these additional curves randomly to create an illusion of volume. This is optional since we are painting loose roses. However, if you want to try this additional step, don't overdo it. Too many curve strokes can make the painting look crowded.

Paint two rosebuds at the lower left of the rose by loading your brush with a milk-like consistency of Cadmium Red Light. Pull two curve strokes side by side on the surface of the paper in a downward motion to suggest the shape of the rosebuds. Leave no gap in between the strokes. While it's still wet, clean your brush thoroughly to avoid a muddy mixture of colors. Load your brush with a coffee-like consistency of Sap Green and paint two leaves using short pointed strokes (page 32) at the bottom of the rosebuds.

Because the Cadmium Red Light is still wet, it will flow to the Sap Green just like in the picture, and that's okay. Don't panic when you see these colors mixing on the paper. That's the wildness of the medium working.

STEP 3: ROSE AND CLUSTERED ROSE BUDS

Using the same method as Step 2, paint another rose above the first one. While the second rose is still wet, paint a cluster of rose buds on the left side of the second rose using milk-like and tea-like consistencies (page 20) of Cadmium Red Light.

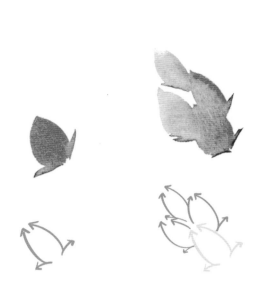

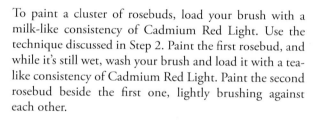

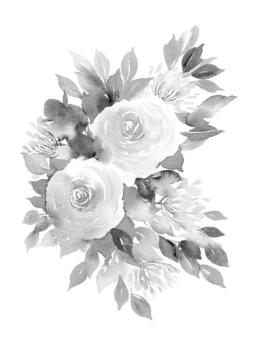

To paint a cluster of rosebuds, load your brush with a milk-like consistency of Cadmium Red Light. Use the technique discussed in Step 2. Paint the first rosebud, and while it's still wet, wash your brush and load it with a tea-like consistency of Cadmium Red Light. Paint the second rosebud beside the first one, lightly brushing against each other.

Repeat the process, alternating the two paint consistencies for a few more rosebuds, then wash your brush thoroughly and load it with a milk-like consistency of Sap Green. Paint pointed leaves at the bottom of the rose buds. You may remember this technique from the Leafy Wreath project (see page 33).

STEP 4: CLUSTERED SPLIT LEAVES AND FILLER FLOWERS

Prepare milk-like and coffee-like consistencies of Sap Green for the leaves and a coffee-like consistency of Aureolin for filler flowers. Set aside.

When I'm in the middle of a new piece, I like to take a step back to check the totality of the painting and add some elements according to my observations. In this painting, I thought I should mirror the clustered rosebud in the upper left, so I added a few on the lower right and added split leaves and filler flowers in random places.

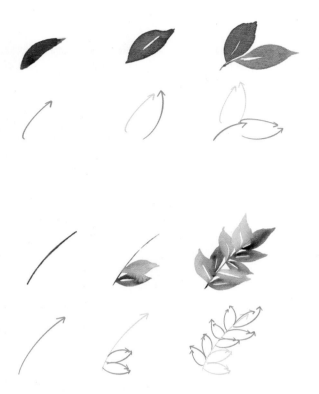

Split leaves can be created with two curve strokes. Paint with upward (or downward) motions while carefully leaving gaps in between the strokes to suggest light. To make it more interesting, use two different paint consistencies for each stroke. I used a milk-like consistency for the first curve stroke, followed by a tea-like consistency for the second curve stroke.

To paint clusters of split leaves, use milk-like and coffee-like consistencies of Sap Green. Load your brush with the milk-like consistency and paint a branch using a semi-heavy stroke (page 28). Then paint leaves, working from the bottom of the branch to the top while alternating between the two consistencies of Sap Green. Brush your strokes together every now and then.

To paint filler flowers, prepare a milk-like consistency of Sap Green and a coffee-like consistency of Aureolin. Load your brush with the Sap Green and apply semi-heavy pressure to paint multiple curve lines that suggest stems. While these are still wet, wash your brush and load the coffee-like consistency of Aureolin, then use the tip of the brush to paint flower buds on the tips of the stems.

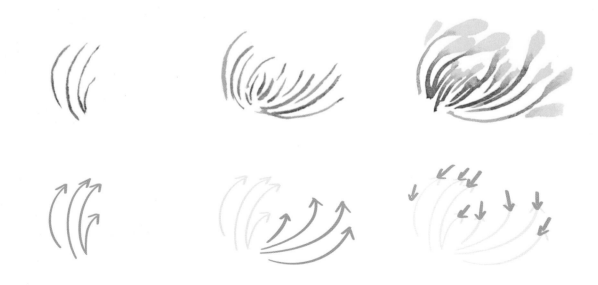

DROPLET STROKE

As the name suggests, a droplet stroke mimics the shape of a water droplet. This shape is very popular for making both leaves and flower petals.

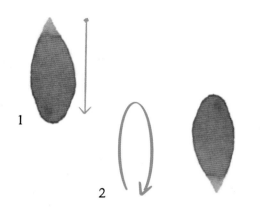

LET'S PRACTICE!

There are two ways to execute this stroke. With practice, you will be able to gauge which way works better for you. Personally, I use the second way more often.

Load your brush with a milk-like consistency (page 20) of any color of your choice. The first method is to start at the narrowest part of the stroke with the tip of your brush, applying semi-heavy pressure (page 28). Gradually increase the pressure as you pull downward with your brush. Lift the brush from the paper slowly.

For the second method, using the tip of your brush, make an upward stroke using semi-heavy pressure, then make a U-turn while applying heavy pressure (page 28). Gradually change to light pressure (page 28) as you head back to the starting point.

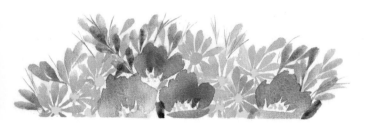

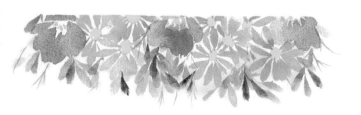

BLUE AND WILD

This is a floral border project in which you will learn how to paint blue wildflowers like felicia daisies and Himalayan poppies with droplet strokes. After painting this project successfully, you can use floral borders to make DIY special occasion cards or invitations.

MATERIALS

Masking or painter's tape

140lb (300gsm), 100% cotton rag, cold-pressed watercolor paper

Painting board

Round brush (page 12)

COLOR PALETTE

Cobalt Blue, Cadmium Yellow Medium, Cobalt Turquoise and Chromium Oxide

STEP 1: PREPARATION

Prepare the materials on your painting table. Using masking or painter's tape, secure your sheet of watercolor paper to a board. This is to prevent the paper from buckling or curling. You can skip this step if you're using a block of watercolor paper.

In this project, you'll also use masking or painter's tape to cover a part of the paper that you don't want to paint on. I used 1-inch (2.5-cm)-wide masking tape. Make sure the tape sticks well on the paper or the water will seep underneath.

STEP 2: BLUE POPPIES

Blue poppies are the main flower in this project, so paint them first in random areas above and below the masking tape. Make the flowers different sizes and use both milk-like and coffee-like consistencies (page 20) of Cobalt Blue for the petals.

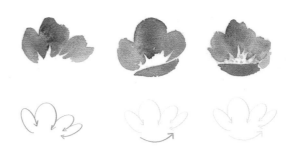

Start by painting three petals side by side with droplet strokes (page 43). Below these, paint another petal horizontally using a curve stroke (page 38). Let it dry, then load your brush with a cream-like consistency (page 20) of Cadmium Yellow Medium and paint dots in between the curve stroke and droplet strokes using the tip of your brush.

STEP 3: BLUE DAISIES

Blue daisies are the second flower in this project. Prepare a milk-like consistency of Cadmium Yellow Medium and milk-like and coffee-like consistencies of Cobalt Turquoise.

To paint blue daisies by the blue poppies, load your brush with a milk-like consistency of Cadmium Yellow Medium and paint a circle. This circle will be the center of a daisy. Let it dry, then proceed with painting petals around the circle with droplet strokes. Alternate using milk-like and coffee-like consistencies of Cobalt Turquoise.

Let it dry.

To paint clusters of blue daisies, load your brush with a milk-like consistency of Cadmium Yellow Medium and make several circles. Make sure that there are gaps between these circles so you'll have space to paint the petals. Start painting petals around one circle with droplet strokes. Normally I paint the one in the center first. Adjust the size of the petals to give the impression of overlapping daisies. Once done, fill out the other circles with petals using droplet strokes in alternating milk-like and coffee-like consistencies of Cobalt Turquoise.

Let it dry.

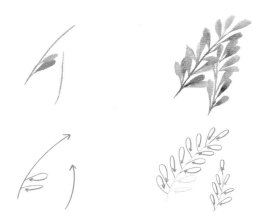

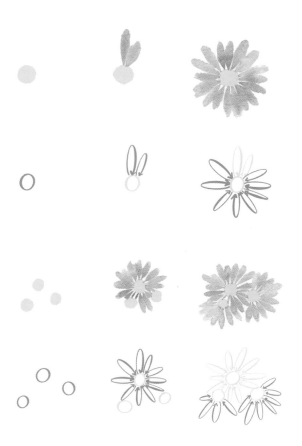

STEP 4: CLUSTER OF ROUND LEAVES

To fill the gaps and add volume to the whole composition, paint clusters of round leaves. Prepare milk-like and coffee-like consistencies of Chromium Oxide and set aside.

To make round leaves, load your round brush with a milk-like consistency of Chromium Oxide and apply semi-heavy pressure to paint simple branches in an upward direction. While the branches are still wet, alternate using the milk-like and coffee-like consistencies of Chromium Oxide to paint the leaves. Start from the bottom of the branch and work toward the top using droplet strokes.

Make sure everything is completely dry, then gently peel off the masking tape.

Brushmarking Practice Projects

Florals, foliage and fruits are enjoyable to paint and are perfect subjects for beginners to polish their strokes for loose watercolor painting. There are a total of four projects in this section, and they are all designed to develop your sense of water-to-paint ratios, color harmony and how much pressure to apply to your brushstrokes.

HARMONIC DAHLIA

I named this painting Harmonic Dahlia because of the palette I chose. As explained in the color harmony formulas (page 15), green-red and blue-orange are complementary colors. Putting them side by side creates a composition with enough contrast for it to be harmonious.

In this project, you will learn how to paint dahlias, snapdragons, chives and blueberry plants. Painting all these elements will let you practice different combinations of strokes using different amounts of pressure.

MATERIALS

Masking or painter's tape

140lb (300gsm), 100% cotton rag, cold-pressed watercolor paper

Painting board

Pencil and eraser

Round brushes, sizes 6 and 10 (page 12)

COLOR PALETTE

Ultramarine, Bright Blue, Sap Green, Cadmium Orange, Indigo and Ruby

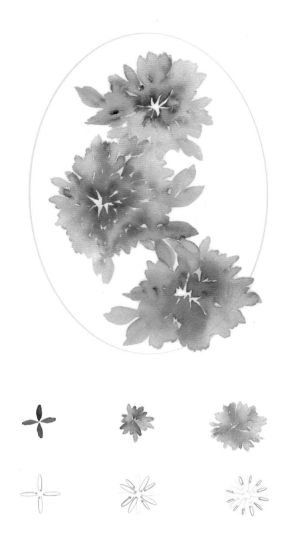

STEP 1: PREPARATION

Prepare the materials on your painting table. Using masking or painter's tape, secure your sheet of watercolor paper to a board. This is to prevent the paper from buckling or curling. You can skip this step if you're using a block of watercolor paper.

Use a pencil to lightly sketch an oval shape on your paper. You will use it as a guide to contain all the elements you'll paint.

STEP 2: DAHLIAS

To paint dahlia flowers, load your size 10 round brush with a mixture of Ultramarine and Bright Blue in a milk-like consistency (page 20) and start painting the center of a dahlia with four droplet strokes (page 43). Lightly rinse your brush until you are left with a coffee-like consistency (page 20) of paint on it, then paint petals with more droplet strokes in between the first four. While doing so, gently brush against the first four strokes to encourage the shades of pigment to flow together. Continue adding petals around the center while alternating paint consistencies until the dahlia reaches your desired size.

Paint three dahlias inside the oval shape. Start in the center of the oval and then add one above the center and one below. While the dahlias are still wet, add pointed leaves to each one, using a coffee-like consistency of Sap Green.

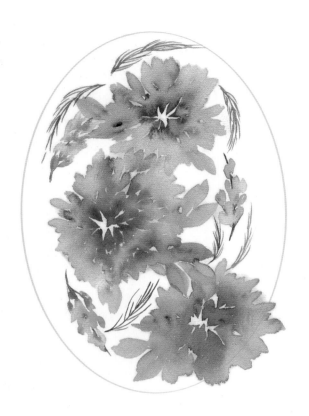

STEP 3: SNAPDRAGONS AND CHIVES

Prepare milk-like and coffee-like consistencies of Cadmium Orange and a milk-like consistency of Sap Green.

Once all the dahlias have dried, add three snapdragons and chives to fill in some of the gaps in the oval shape.

To paint a snapdragon, load your size 6 round brush with a milk-like consistency of Cadmium Orange and start with one droplet stroke. Lightly rinse your brush until you are left with a coffee-like consistency of the same color on your brush, and paint a droplet stroke beside the first one. Continue to add more droplet strokes above the first two as you work your way up. Let each stroke brush against each other to encourage fluidity. These droplet strokes are your snapdragon petals.

While the petals are still wet, load your brush with a milk-like consistency of Sap Green and paint a branch starting from the bottom and passing through the petals.

To paint chives, load your brush with a milk-like consistency of Sap Green. Using semi-heavy pressure (page 28), start painting a branch-like structure to guide you. Using the same pressure, paint the rest of the chives along the "branch" with upward strokes.

<div align="center">

SNAPDRAGON CHIVES

</div>

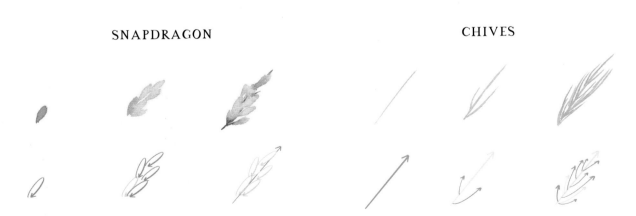

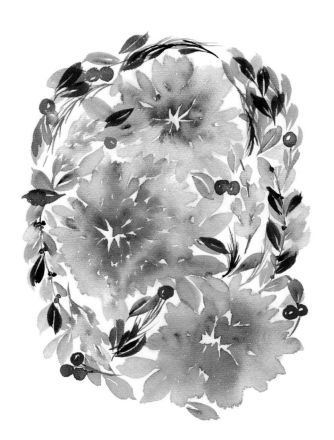

STEP 4: BERRIES

In this step, the goal is to add more contrast to the composition. Prepare milk-like and tea-like consistencies (page 20) of Sap Green and milk-like consistencies of Indigo and Ruby.

Load your size 6 round brush with a milk-like consistency of Indigo and paint small berries with two curve strokes (page 38) to form a circle, leaving a small gap to suggest light. Paint them in a diagonal formation, starting with two pairs, then another two pairs slightly above the first pairs of berries and lastly one more berry slightly on the right above the second pair.

While the berries are still wet, quickly rinse the Indigo from your brush and load it with a milk-like consistency of Sap Green to paint the branch that passes through to the berries. Once done, paint split leaves along the branch, alternating between milk-like and tea-like consistencies of Sap Green. You may remember this technique from the Melody of Roses project (see page 38).

Lastly, paint red berries in random places to enhance the contrast. To paint berries, load your brush with a milk-like consistency of Ruby. As with the Indigo berries, paint two curve strokes to form a circle while leaving a small gap to suggest light.

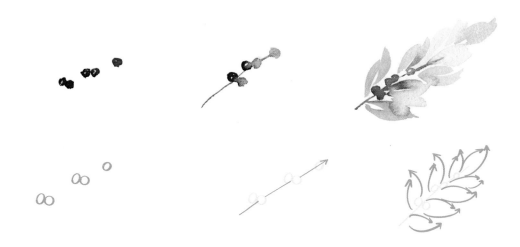

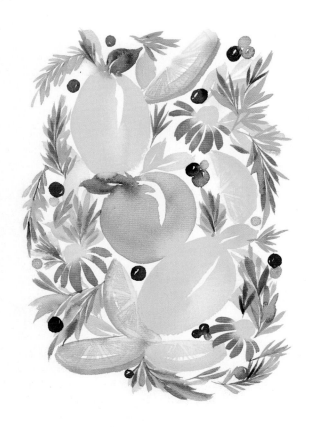

CITRUS FEST

This is one of my favorite compositions because of the fresh vibe it gives, and because I love painting patterns. In this project, you will learn the step-by-step process of painting oranges, lemons, coneflowers and sage.

MATERIALS

Masking or painter's tape

140lb (300gsm), 100% cotton rag, cold-pressed watercolor paper

Painting board

Round brush (page 12)

COLOR PALETTE

Golden Deep, Aureolin, Sap Green, Quinacridone Rose and Indigo

STEP 1: PREPARATION

Prepare the materials on your painting table. Using masking or painter's tape, secure your sheet of watercolor paper to a board. This is to prevent the paper from buckling or curling. You can skip this step if you're using a block of watercolor paper.

STEP 2: CITRUS SISTERS

Prepare milk-like and coffee-like consistencies (page 20) of Golden Deep, Aureolin and Sap Green to paint oranges, lemons and leaves.

Start with an orange in the middle part of the paper. Load your brush with a milk-like consistency of Golden Deep and paint two thick curve strokes (page 38) facing each other with a gap in between. Once done, rinse your brush and reload it with a coffee-like consistency of Golden Deep to fill in the lower gap between the two curves. It is very important to fill in the gap while the two thick curve strokes are still wet and to leave a medium-sized gap on the top of the orange to suggest light.

While the orange is still wet, load your brush with a milk-like consistency of Sap Green and paint split leaves at the top of the orange. Create split leaves by painting two curve strokes with a gap in between (see page 42).

While the orange is still wet, paint lemons above and below it, gently brushing against the orange to encourage the colors to interact. To paint lemons, load your brush with a milk-like consistency of Aureolin. Start with a diagonal stroke, applying heavy pressure (page 28). While this stroke is still wet, lightly rinse your brush until just a coffee-like consistency of paint is left on it. Apply heavy pressure and make a curve stroke from top to bottom.

You can stop here to suggest a sliced lemon or orange. Otherwise, add another curve stroke on the other side to make a whole lemon.

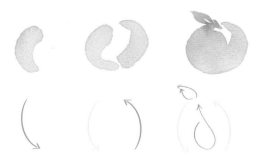

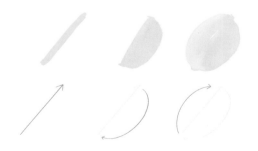

STEP 3: CITRUS SLICES AND CONEFLOWERS

Prepare milk-like and coffee-like consistencies of Aureolin and a coffee-like consistency of Quinacridone Rose.

Paint three coneflowers beside the orange and lemons. To paint a coneflower, load your brush with a milk-like consistency of Aureolin and paint a circle for the head of the coneflower. While the dome is still wet, load your brush with the Quinacridone Rose. Applying semi-heavy to heavy pressure, paint multiple petals with curve strokes in a semicircle formation, meaning both ends will be shorter compared to the petals in the middle section.

While painting the curve strokes, gently tap the dome as you pull each stroke toward you. In doing so, Aureolin and Quinacridone Rose will interact with each other, provided they are still wet.

After painting the coneflowers, paint several slices of oranges and lemons by following the instructions in Step 2, but stopping before painting the second curve stroke. The beauty of painting patterns is the freedom you have to paint on any part of the canvas. I'm not saying you should go crazy, but stay loose!

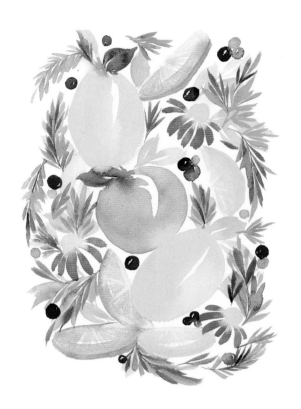

STEP 4: FOLIAGE AND BERRIES

Now to unify the composition. Add berries and sage to fill in the empty spaces on the paper. For the sage foliage, use milk-like and coffee-like consistencies of Sap Green. For the berries, prepare a milk-like consistency of Indigo.

Like any other foliage we have painted so far, start by making a branch. Apply light pressure (page 28), and make an upward stroke to your desired length. Then paint some leaves by alternating the milk-like and coffee-like consistencies of Sap Green. Let the pigment interact by gently brushing your strokes against each other.

For the sake of variety in the composition, use droplet strokes (page 43) for some leaves and pointed strokes (page 32) for others.

As in the Harmonic Dahlia project (page 46), you can paint berries with two curve strokes to form a circle with a small gap to suggest light (see page 36).

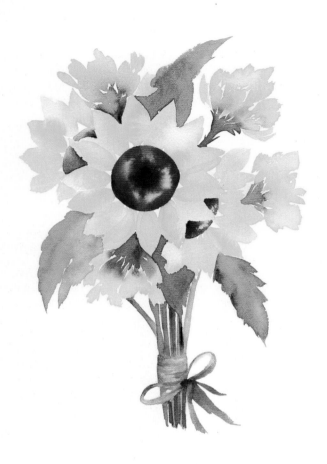

BOUQUET OF SUNSHINE

Sunflowers are the very symbol of summer. With their bright yellow petals and tall green stems, it's easy to see why so many people love them and why so many artists love painting them. In this project, we will learn how to paint this cheerful flower.

MATERIALS

Masking or painter's tape

140lb (300gsm), 100% cotton rag, cold-pressed watercolor paper

Painting board

Round brush (page 12)

Pencil and eraser (optional)

COLOR PALETTE

Aureolin, Raw Sienna, Sepia, Sap Green and Cobalt Blue

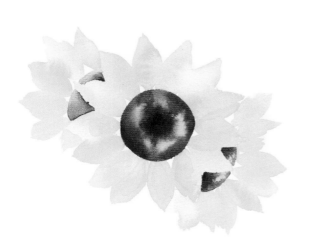

STEP 1: PREPARATION

Prepare the materials on your painting table. Using masking or painter's tape, secure your sheet of watercolor paper to a board. This is to prevent the paper from buckling or curling. You can skip this step if you're using a block of watercolor paper.

STEP 2: SUNFLOWER

Prepare milk-like and coffee-like consistencies (page 20) of Aureolin and milk-like consistencies of Raw Sienna and Sepia to make sunflowers.

You will start with a confident sunflower in the middle and two shy sunflowers beside it.

To paint the confident sunflower, load your round brush with a coffee-like consistency of Aureolin and paint a circle as the center of the sunflower. While it is still wet, paint two curve strokes (page 38) inside the circle with a milk-like consistency of Raw Sienna. Let the two colors interact with each other while you rinse your brush and load it with a milk-like consistency of Sepia. While the center of the sunflower is still wet, add the Sepia mixture in the center of the circle. Let it dry while these three colors interact with each other.

The petals of the sunflower are slightly wide and pointy, so it's best to paint them with pointed strokes (page 32) while applying heavy pressure (page 28). Paint the pointed petals around the circle by alternating consistencies of Aureolin. Let it dry.

To paint the two shy sunflowers, trace the tip of the petals on the lower right and upper left of the confident sunflower and paint semicircles outside of it with a coffee-like consistency of Aureolin. While the Aureolin is still wet, add a milk-like consistency of Sepia in the inner part of the semicircles. Let it dry, then proceed with painting pointed petals around the semicircles, alternating milk-like and coffee-like consistencies of Aureolin. Let it dry.

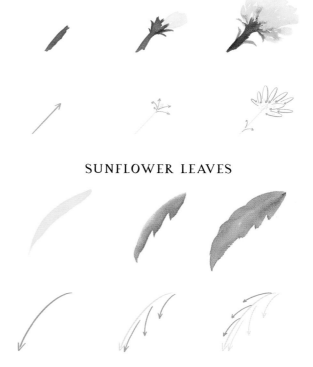

SUNFLOWER LEAVES

STEP 3: SUNFLOWER BLOOMS AND LEAVES

Prepare a milk-like consistency of Sap Green and milk-like and coffee-like consistencies of Aureolin.

When all three sunflowers are dry, paint four blooming sunflowers with leaves around them. Let it dry. I don't have a methodology to know exactly where I should put the leaves in a bouquet. I just use my creative instinct to map it out—a skill that took me long hours of practice to develop. However, it looks nice when I use the gap on my flowers to paint the leaves.

To make sunflower blooms, load your brush with a milk-like consistency of Sap Green and apply semi-heavy pressure (page 28) to paint a branch with an upward stroke. Then proceed to paint the base of the flower with multiple pointed strokes. While the base of the flower is still wet, load your brush with a milk-like consistency of Aureolin and paint the petals with curve strokes, alternating milk-like and coffee-like consistencies.

Painting sunflower leaves is just my favorite! Start by preparing milk-like consistencies of Sap Green and Aureolin. Paint long pointy strokes, applying a combination of heavy to light pressure (page 28). This will serve as the center of the sunflower leaf.

While the center of the leaf is still wet, make several pointed strokes outward to suggest a jagged shape. It is easy to start at the top of the leaf and pull downward. Repeat this process for the other side of the leaf.

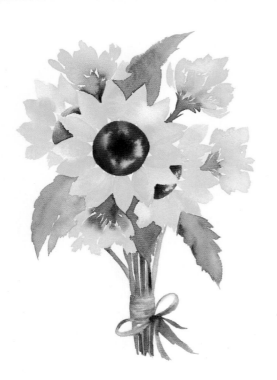

STEP 4. OPTION A: WITHOUT RIBBON

Paint the stems of the sunflowers by making multiple heavy downward strokes from the edge of the leaves and petals. Use a milk-like consistency of Sap Green.

STEP 4. OPTION B: WITH RIBBON

Bold move to choose the ribbon! This element is optional, but it adds a little something extra to your sunflower bouquet. Now, estimate the distance between the ribbon and the flowers. While doing so, imagine the stems connecting the ribbons to the flowers. If you're satisfied with the distance, paint the ribbon by making a cylinder shape with a coffee-like consistency of any color you choose. I chose Cobalt Blue. Feel free to sketch the ribbon if you're more comfortable with working against a guide, but you can also use the tip of your brush to estimate the shape. Let it dry.

Once the cylinder shape is dry, use the tip of your brush to paint a number eight or infinity symbol on the lower right corner of the cylinder. From the center of the infinity symbol, pull three pointed strokes and that's it!

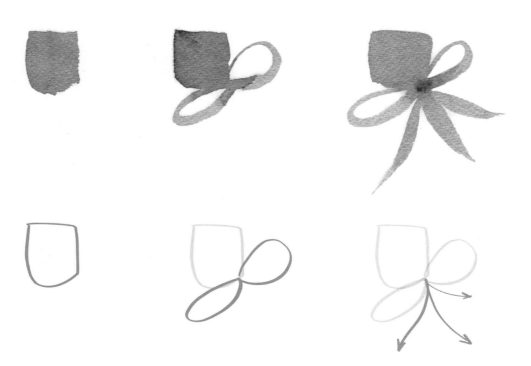

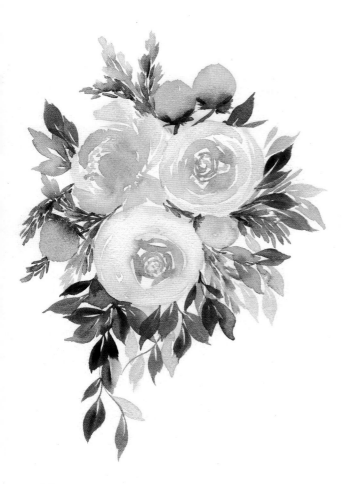

BLUSHING PEONIES

The soft petals, elegant shape, delicate shades and exquisite fragrance make this flower an all-time favorite. So for our last brushmarking project, we will learn how to paint—drum roll please—peonies!

MATERIALS

Masking or painter's tape

140lb (300gsm), 100% cotton rag, cold-pressed watercolor paper

Painting board

Round brush (page 12)

COLOR PALETTE

Quinacridone Rose, Cadmium Yellow Medium and Sap Green

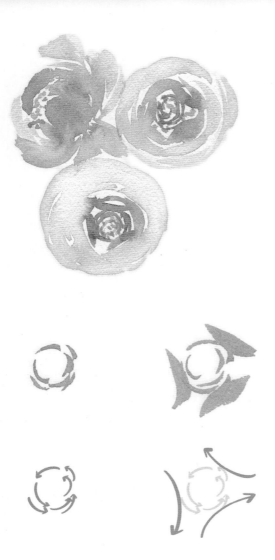

STEP 1: PREPARATION

Prepare the materials on your painting table. Using masking or painter's tape, secure your sheet of watercolor paper to a board. This is to prevent the paper from buckling or curling. You can skip this step if you're using a block of watercolor paper.

STEP 2: PEONIES

Prepare coffee-like and milk-like consistencies (page 20) of Quinacridone Rose and a cream-like consistency (page 20) of Cadmium Yellow Medium.

Start by making two open peonies and one face-up peony in the middle of the page as the main focus of the composition. It is natural to base the position of all the other elements of a painting around the main subject—in this case, the peonies.

To make an open peony, load your brush with a milk-like consistency of Quinacridone Rose, imagine a small circle and use light pressure (page 28) to paint multiple curve strokes (page 38) outside the circle. This forms the center of the peony.

Once done, use semi-heavy pressure (page 28) to paint three curve strokes that face outside the center of the peony. These three strokes will suggest medium-sized petals.

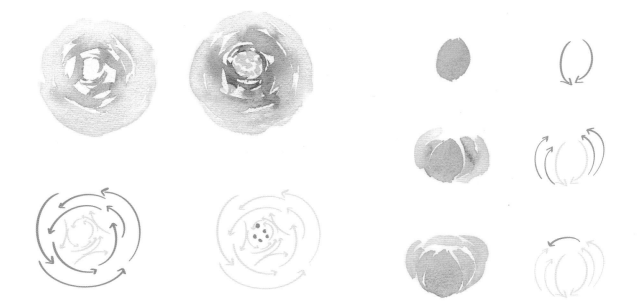

To suggest bigger petals, load your brush with a coffee-like consistency of Quinacridone Rose and use heavy pressure (page 28) to paint curve strokes around the medium petals. Brush lightly against the center of the peony.

While the petals are still wet, stipple dots with a milk-like consistency of Cadmium Yellow Medium in the center of the peony and on the leaves. These dots are the pollen. Because the petals are still wet, the Cadmium Yellow Medium will flow and mix with the Quinacridone Rose. This will make your peony more beautiful!

Let it dry.

As with the open peonies, prepare the following mixtures of colors for the face-up peony: milk-like and coffee-like consistencies of Quinacridone Rose, a milk-like consistency of Cadmium Yellow Medium and a milk-like blend of Cadmium Yellow Medium and Quinacridone Rose.

Load your brush with a milk-like consistency of Quinacridone Rose and use semi-heavy pressure to paint a petal that is composed of two curve strokes facing each other. Once done, rinse your brush and load it with a milk-like blend of Cadmium Yellow Medium and Quinacridone Rose to paint multiple curves surrounding the first petal while leaving a gap in the middle.

Add more petals with a coffee-like consistency of Quinacridone Rose by pulling multiple curve strokes under the first petal. While the petals are still wet, stipple dots with a milk-like consistency of Cadmium Yellow Medium to suggest pollen. Let it dry.

STEP 3: PEONY BUDS

Prepare three colors for this element: a coffee-like consistency of Cadmium Yellow Medium, a milk-like consistency of Quinacridone Rose, and a milk-like consistency of Sap Green.

Load your brush with a milk-like consistency of Quinacridone Rose and apply heavy pressure to paint a curve stroke near the main peony. While this stroke is still wet, rinse and load your brush with a coffee-like consistency of Cadmium Yellow Medium. Apply heavy pressure to paint another curve stroke facing the first one. Fill in any gaps between the two strokes. These combined curve strokes will suggest a peony bud.

While the peony bud is still wet, rinse your brush and load it with a milk-like consistency of Sap Green. Add leaves by pulling multiple pointed strokes (page 32) from the bottom part of the peony bud. Let it dry or you can add a stem with split leaves on the side.

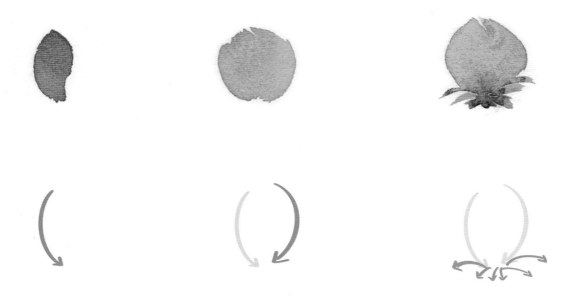

STEP 4: FOLIAGE

To bridge the gap between the flowers and lessen the blank space on the paper, add sage in random areas around the peonies using milk-like and coffee-like consistencies of Sap Green. You may remember this technique from the Citrus Fest project (see page 50). Load your brush with a milk-like consistency of paint and apply light pressure to make a stroke that suggests a branch. While the branch is still wet, start at the bottom and paint leaves with droplet strokes (page 43). Switch to the coffee-like consistency of Sap Green as you work your way up the branch.

To unify the rest of the composition, paint clusters of split leaves by alternating the same two consistencies of Sap Green that you used for the sage foliage. Doing so will create contrast. You may remember this technique from the Melody of Roses project (see page 38). Load your brush with a milk-like consistency of Sap Green and apply semi-heavy pressure to make a stroke that suggests a branch. Start making leaves at the bottom of the branch and work your way up, alternating consistencies of Sap Green.

SAGE

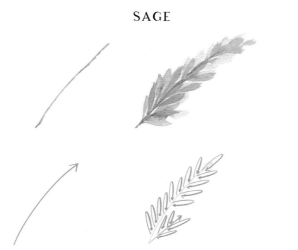

SPLIT LEAVES

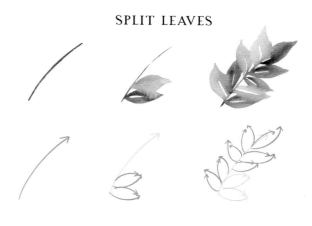

Watercolor Techniques

Welcome to the final goal in building your basic knowledge about loose watercolor painting. Learning about different watercolor techniques will help you understand the medium's true beauty, its luminosity and the delicious ways the colors blend. You'll see that watercolor painting welcomes surprises and wildness.

This chapter is carefully designed to help you navigate the unpredictability of this medium. All the basic watercolor technique descriptions are accompanied by practice projects. These projects begin with a scene study to help you become familiar with the elements of the paintings, followed by sketching guidance and finally the application of the specific techniques. We will start exploring the most basic techniques and add complexity as we go along.

By the time you finish all the projects in this book, you will notice definite signs of improvement in your painting skills. There might be failures along the way, but I suggest that you embrace all mistakes and imperfections that may come along, because it is nothing but normal. Mistakes are part of the experience and part of the journey that all artists undergo. The most important thing is for you to enjoy this guided process so you can produce an enjoyed piece of artwork.

Three Main Techniques in Watercolor

The three main watercolor techniques are dry-on-dry, wet-on-dry and wet-on-wet.

DRY-ON-DRY

Also known as "dry brush," this technique requires no water on the paper and minimal water on the brush to create hard and broken edges.

WET-ON-DRY

This technique is what we've been using in the practice projects up to this point. It is a technique that uses a wet, loaded brush on dry paper.

WET-ON-WET

This technique involves applying wet paint to a wet area of paper and will be explored in more detail later in the chapter.

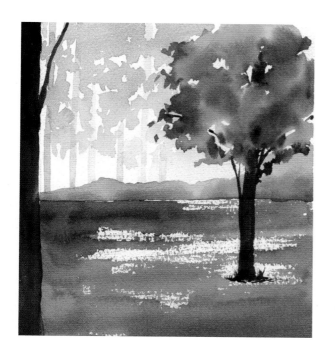

WOODLANDS

In this project, we'll take a deeper look at the wet-on-dry techniques we've previously discussed and incorporate them into your first landscape. Are you excited? I am for you! This project will give you a more detailed understanding of the wet-on-dry technique as you paint trees, trunks and bushes. You'll also practice the dry-on-dry technique by painting a field of grass. So, let's get this landscape project started!

MATERIALS

Masking or painter's tape

140lb (300gsm), 100% cotton rag, cold-pressed watercolor paper

Painting board

Pencil and eraser

Round brushes, sizes 8 and 10 (page 12)

COLOR PALETTE

Sap Green, Burnt Sienna, Aureolin, Golden Deep and Sepia

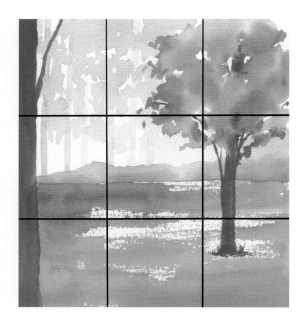

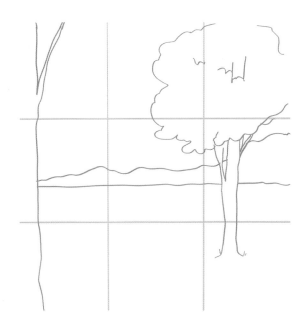

STEP 1A: PREPARATION

Prepare the materials on your painting table. Using masking or painter's tape, secure your sheet of watercolor paper to a board. This is to prevent the paper from buckling or curling. You can skip this step if you're using a block of watercolor paper.

STEP 1B: SCENE STUDY

Take a look at the finished painting and use the grid overlay to familiarize yourself with where the elements are located.

This grid strategy is one that artists use to develop their compositions and create realistic scenes. It involves drawing a grid over your reference photo, and then drawing a grid of equal ratio on your work surface. In this book, we will use it a little differently. Instead of aiming for an exact reproduction, we will use the grid method as a placement guide for the individual elements that are pictured.

In this painting, we can see that the main part of the tree is found in the third, sixth and ninth blocks, with tree foliage in the second and fifth blocks. The bushes are in the fourth through sixth blocks, grasses are in the seventh through ninth blocks and the foreground tree is in the first, fourth and seventh blocks.

STEP 1C: SKETCHING

With the help of the grid overlay, start sketching the shapes of the elements very lightly. In this painting, the key elements are a tree, some bushes, grasses and the foreground tree trunk.

Pictured is a guide that can help you with your sketch.

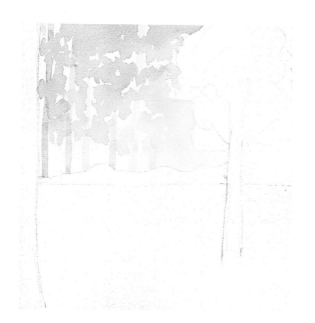

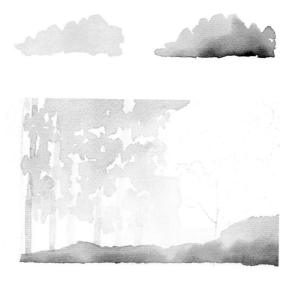

STEP 2: DISTANT TREE FOLIAGE AND TRUNKS

Using coffee-like consistencies (page 20) of Sap Green and Burnt Sienna and a size 8 round brush, paint some distant tree foliage and tree trunks. Using a lighter consistency of paint will create an illusion that the element is farther away than the ones painted with a stronger consistency.

To paint the foliage, imagine the general shape of it and paint that. In loose watercolor painting, there is no need to paint every leaf or every part of the subject. Just remember to leave some gaps in between. Once done, add some tree trunks.

STEP 3: BUSHES

When painting bushes, you only need to establish their shape to suggest them effectively. Let's start by preparing a coffee-like consistency of Aureolin and a milk-like consistency (page 20) of Sap Green and Golden Deep.

Load your size 8 round brush with a coffee-like consistency of Aureolin and paint the shape of the bushes. Once you've got that covered, add a milk-like consistency of Sap Green on most parts of the lower bushes and a milk-like consistency of Golden Deep on the upper part of the bushes. Let the colors interact with each other and let it dry.

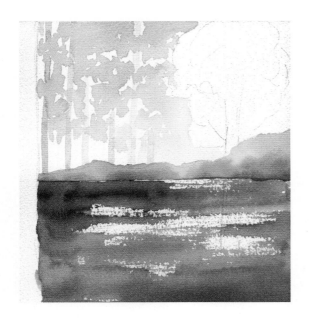

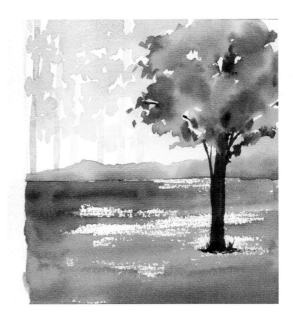

STEP 4: GREEN GRASS FIELD

Load your semi-damp size 10 round brush with a milk-like consistency of Sap Green. Holding the brush with a baton grip (page 26) and applying heavy pressure (page 28), perform a dry-on-dry technique (see page 66) to suggest the field of grass. The broken hard edges will suggest light on the grasses. Let it dry.

STEP 5A: TREE

To paint a tree, start with the foliage. Load your size 8 round brush with a coffee-like consistency of Aureolin, then blend with a milk-like consistency of Sap Green and Golden Deep. Take note that you need to focus on the general shape of the tree foliage.

While the foliage of the tree is still wet, load your brush with a milk-like consistency of Sepia. Apply heavy pressure and paint from the bottom to the top. Once you're done, paint some branches extending outward from the trunks, applying semi-heavy to light pressure (page 28) to your strokes.

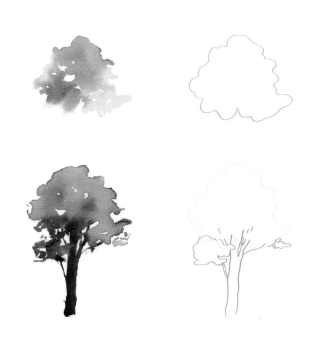

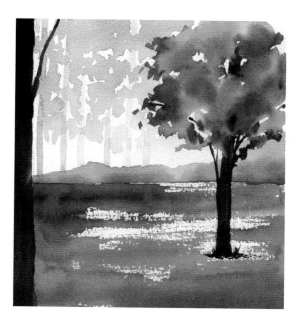

STEP 5B: FOREGROUND

For the final step of your first landscape painting, load your size 8 round brush with a cream-like consistency (page 20) of Sepia and paint a tree trunk in the left-hand corner of the painting.

WET-ON-WET

This technique involves applying wet paint to a wet area of paper. Earlier you learned the Tea-to-Butter analogy of water-to-paint ratios (page 20). In this section, we are going to explore the relationship between water and paper. A comprehensive knowledge of the relationships between water, paint and paper will help you lessen the unpredictability of this medium.

FOUR STAGES OF PAPER WETNESS

There are four stages of paper wetness, and pigment reacts differently in the presence of each one.

SOAKED

Soaked paper is very wet and shiny or glossy. When you tilt your board or block of paper in this stage, the pigment will flow nicely in any direction you want. This stage is a good one for making washes and backgrounds and mixing colors on the surface of the paper. It is also the most forgiving stage, as any mistake is easily resolved when the paper is soaked.

MOIST

At this stage, the paper is not soaked but still has a gloss. As in the previous stage, moist paper is generally good for mixing colors on the surface, but the likelihood of creating watercolor blooms is minimal. It is also easier to control the pigments compared to the soaked stage.

DAMP

Damp paper is almost dry. This stage is ideal for certain techniques, like creating blooms and water splatter, that we will explore later in the chapter. But generally, I am very careful about doing anything to my painting while it is damp, because it is very easy to create unnecessary and unwanted marks during this stage.

DRY

As the name suggests, the paper at this stage is dry. Dry paper does not have any water interaction at all and any water that was applied earlier is already dried up.

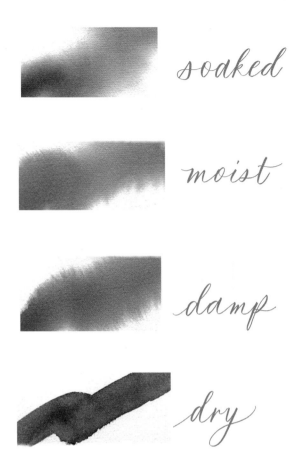

soaked

moist

damp

dry

LET'S PRACTICE!

This exercise will help prepare you to handle the wet-on-wet technique by demonstrating how paint reacts to the different stages of paper wetness. Take your time and practice this exercise multiple times, as the insights you gain will be very useful in your watercolor painting.

Begin by dividing your paper into four sections with masking tape. Wet each section of the paper to varying degrees using a flat brush (page 12) and load your round brush (page 12) with a milk-like consistency (page 20) of any color of your choice. Observe the stages of wetness on the paper and paint a bold stroke that spans a few different stages.

You'll notice that the stroke on the soaked paper does not produce crisp edges, and the moist paper produces soft edges. Damp paper will give you a slightly blurred and feather-like edge, while painting on a dry paper will give you an edge with lots of definition.

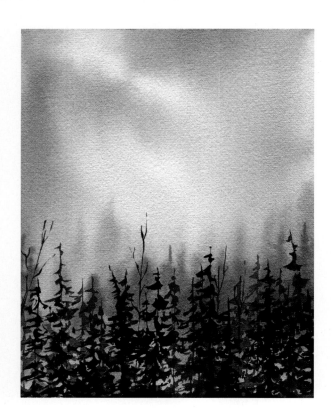

ATMOSPHERIC LANDSCAPE

Atmospheric landscapes are one of the most popular watercolor compositions, and one that most emerging artists are fond of painting. I've personally been obsessed with painting atmospheric, airy landscapes because they give off a mysterious vibe that I love. In this project, the goal is to familiarize yourself with how pigment flows on different stages of wet paper.

The key to this project is patience. As you practice the wet-on-wet technique, it is very crucial that you stay kind to your painting and to yourself. Remember that you've come a long way and this is going to be very exciting! Projects like this one helped me embrace the wildness of watercolor painting. Now it's your turn to do some guided exploration.

MATERIALS

Masking or painter's tape

140lb (300gsm), 100% cotton rag, cold-pressed watercolor paper

Painting board

Pencil and eraser

Flat wash brush or mop brush (page 12)

Round brushes, sizes 6 and 10 (page 12)

COLOR PALETTE

Payne's Gray

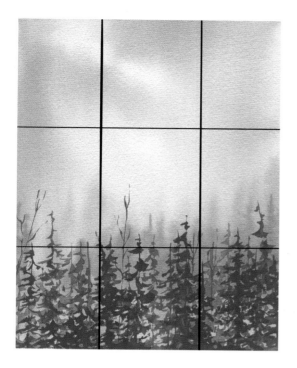
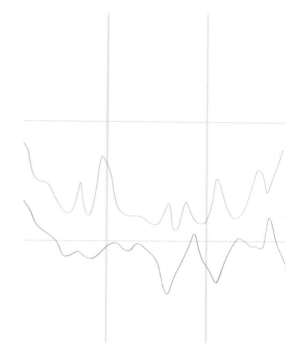

STEP 1A: PREPARATION

Prepare the materials on your painting table. Using masking or painter's tape, secure your sheet of watercolor paper to a board. This is to prevent the paper from buckling or curling. You can skip this step if you're using a block of watercolor paper.

STEP 1B: SCENE STUDY

With the paper in portrait orientation, sketch the outline of the pine tree peaks.

Use the grid overlay to conduct a scene study of the example painting. The outline of the most distant trees is in the middle of the fourth through sixth blocks. The middle trees are slightly overlapping the most distant trees. The foreground pine trees are primarily in the seventh through ninth blocks, but the outlines are slightly overlapping the middle trees.

STEP 1C: SKETCHING

There are two key elements in this painting: the pines and the sky. However, there is no need to sketch the sky in this project, so you will only be sketching the outline of the pine trees alone.

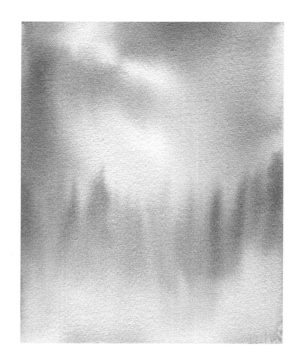

STEP 2: SKY AND BACKGROUND

To start, wet the surface of the paper evenly using a flat wash brush or a mop brush, making sure there's no big puddle on the paper. Then load your size 10 round brush with a milk-like consistency (page 20) of Payne's Gray and make a stroke in the upper left corner of the paper. Let the paint flow on the soaked paper. Paint a second stroke below the first one, leaving a gap in between to suggest light.

Lightly rinse your brush until a coffee-like paint consistency (page 20) remains and paint on the rest of the surface of the paper. Let the paper lay flat until it dries.

Make sure the paper is completely dry before you re-wet it for the next step. Otherwise, when you start painting trees, they will blend into the sky, and the distinction between those two separate elements will be lost.

STEP 3: DISTANT GROUP OF TREES

Re-wet the paper evenly until moist (page 72), using a flat brush or mop brush, then load your size 6 round brush with a coffee-like consistency of Payne's Gray and paint the most distant group of pine trees.

To paint a group of trees in the distance using the wet-on-wet technique (see page 72), tilt the upper part of the paper 80 degrees. Now use the outline you sketched in Step 1C as a guide for a loose, sweeping stroke, called a gestural stroke, applying light to semi-heavy pressure (page 28). Let gravity take over for a moment, and then let the paper dry flat.

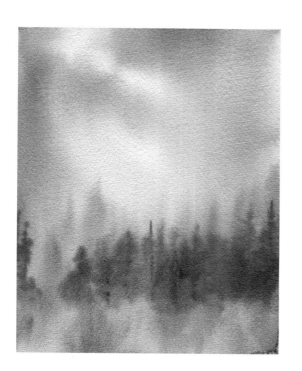

STEP 4: MIDDLE TREES

Repeat Step 3 with a milk-like consistency of paint on your size 6 round brush and on moist paper. This time you want the shape of the pine trees to look a little more distinct than the previous ones, but you also want them to have a slightly misty look.

To paint a pine tree, start with its trunk first so you'll have a guide. With your loaded brush, apply light pressure to paint an upward stroke that suggests a skinny tree trunk.

Once done, paint the foliage with gestural marks that are similar to curve strokes (page 38), starting at the tree trunk and working outward. Use the tip of your brush with combinations of different amounts of pressure. Remember that trees aren't symmetrical, so flick your brush erratically to create its form without details.

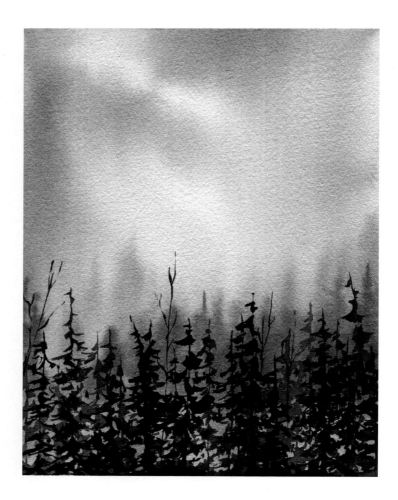

STEP 5: FOREGROUND

For the final step, make sure the paper is completely dry. Load your size 6 round brush with a coffee-like consistency of paint and paint a layer of foreground pine trees. Let it dry, then paint another layer of pine trees and bare trees using a milk-like consistency of paint.

Laying a Wash

A wash creates the basis for a watercolor painting. More often than not, the wash suggests the mood or sets the tone of paintings. Watercolor washes are applied to areas that are usually too big to cover with only one stroke.

In this chapter, you will learn the four basic watercolor washes: flat wash, gradient wash, variegated wash and irregular wash. Most artists use these washes for skies, backgrounds and any space that requires an application of smooth or integrated color.

A flat wash is a single-color wash that doesn't have any variation and is uniformly applied to all the corners of the desired area.

A gradient wash features a smooth, gradual change in tone from dark to light. It is a transition between consistencies of pigment on the paper.

There are two methods that I use to create flat and gradient washes. One uses the wet-on-dry technique, and the other uses the wet-on-wet technique (see page 72). I recommend practicing both methods to determine which one you find easier and are more comfortable with. Remember that you need to change the consistency of your paints in order to make a gradient wash, whereas a flat wash has a consistent color value throughout.

Flat

Variegated

Gradient

Irregular

WET-ON-DRY FLAT AND GRADIENT WASH APPLICATION

STEP 1:

Prepare a coffee-like consistency (page 20) of Ultramarine or any color of your choice. Make sure you prepare enough to cover the targeted area of the paper. It is better to have some excess paint leftover than to risk having your paper dry prematurely while you take time to mix more.

Incline the board with your watercolor paper or your block by propping up the back edge. A 30-degree angle is sufficient, or you could just put a roll of masking tape behind the board to elevate the upper part.

STEP 2:

With your loaded brush, paint a horizontal line across the top of the paper. The paint will flow down the paper, and the excess moisture will accumulate at the end of a stroke. This is known as a bead.

STEP 3A:

Continue to paint horizontal brush strokes, alternating the starting point from left to right. Each brush stroke should be a little lower down the page and slightly overlap the previous stroke. This will slowly push the bead farther down the page. The next steps will differentiate the wash you'll do.

STEP 3B: FLAT

Attain a flat wash by continuing the strokes with the same consistency of paint until you reach the end of the page.

STEP 3B: GRADIENT

In the area you want your wash to be lighter, load your brush with a tea-like consistency (page 20) of your chosen color and continue to paint horizontal strokes with your brush.

STEP 4:

Don't let your brush dry out. Make sure you always have a bead forming at the bottom of your stroke. When you reach the end of your wash, use a tissue or cloth to blot away the bead.

WET-ON-WET FLAT AND GRADIENT WASH APPLICATION

STEP 1:

Pre-wet the paper using a flat brush or hake, making sure that the water is applied evenly. While you wait for the paper to dry slightly so that it is moist, prepare a milk-like consistency (page 20) of any color of your choice. Make sure that you prepare enough to cover the whole area of the paper.

STEP 2A:

When the paper is moist, start making horizontal strokes. You have better control over how the paint flows on the paper when it is moist and your pigment consistency is milk-like. Work fast at this stage because the moistness of paper is short lived. The next step will determine the kind of wash you will execute.

STEP 2B: FLAT WET-ON-WET WASH

Move your loaded brush evenly across the whole surface of the paper as quickly as possible while the paper is still soaked. Eliminate any excess paint by letting it seep to one side and blotting up the excess moisture with a tissue or cloth to avoid backruns.

STEP 2B: GRADIENT WET-ON-WET WASH

Similar to the wet-on-dry technique for a gradient wash (page 80), lighten the paint consistency you apply to the area where you want your wash to be lighter. On your way down the page, lightly rinse your brush until a coffee-like consistency of paint remains. Near the bottom of the page, switch to a tea-like consistency of paint.

STEP 3:

Finish the wash by blotting away any excess moisture at the base.

Now that you've learned about flat and gradient washes, we are moving on to the other two types of washes: variegated wash and irregular wash. A variegated wash smoothly transitions from one color to another. This wash is easier to do on a wet surface, but it is doable on dry paper as well.

LET'S PRACTICE!

Prepare milk-like consistencies (page 20) of Quinacridone Lilac, Quinacridone Rose and Aureolin. Set aside. Using a flat brush, hake brush or mop brush (page 12), wet the paper where you will lay down your wash. Make sure the surface of the paper is evenly wet.

Once your paper is soaked (page 72), load a size 10 round brush with Aureolin and apply it to the bottom part of the page. Rinse your brush quickly and load it with Quinacridone Lilac to paint on the top of the page. At this stage your paper is going to be moist already, so quickly rinse your brush, load it with Quinacridone Rose and apply it to the middle of the page while blending it to both Quinacridone Lilac and Aureolin.

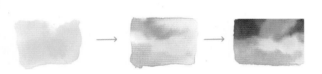

An irregular wash is similar to a variegated wash, but it is a more random, painterly way of blending colors. Unlike the other three types of washes, this wash is only executed on wet surfaces. This technique is fun and loose, and it allows you to just play with colors. This is the wash I use most often to paint skies, meadows and other scenic backgrounds!

LET'S PRACTICE!

Prepare milk-like consistencies (page 20) of Aureolin, Golden Deep and Cadmium Orange, and a milk-like blend of Cadmium Orange and Ultramarine.

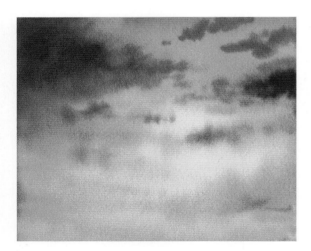

With a flat brush (page 12), pre-wet the paper evenly until soaked (page 72) and apply Aureolin using a size 10 round brush (page 12) on most parts of the paper. Quickly rinse your brush, load it with Golden Deep and paint the upper and lower part of the paper. Next, apply Cadmium Orange to all four corners. Let these colors blend on the paper while you wait for the paper to reach the moist stage (page 72).

Once the paper is moist, lay down the Cadmium Orange and Ultramarine blend on the upper right and middle part of the paper.

The next four projects will help you practice the application of these four washes.

SUNNY DAY

Now that you have been exposed to the various types of washes, it is about time to dig into more practice. In this project, we will be using a warm analogous color scheme to convey a sunny day. We will also practice using a flat wash for the background of the painting.

MATERIALS

Masking or painter's tape

140lb (300gsm), 100% cotton rag, cold-pressed watercolor paper

Painting board

Pencil and eraser

Flat brush (page 12)

Round brush (page 12)

COLOR PALETTE

Golden Deep, Aureolin and Cadmium Orange

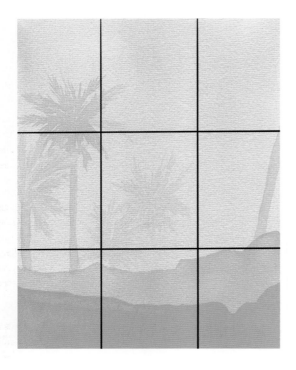

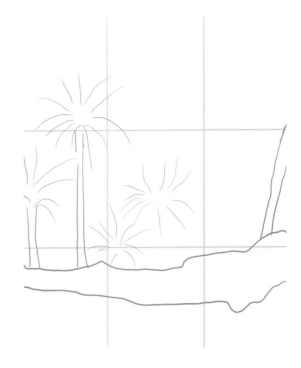

STEP 1A: PREPARATION

Prepare the materials on your painting table. Using masking or painter's tape, secure your sheet of watercolor paper to a board. This is to prevent the paper from buckling or curling. You can skip this step if you're using a block of watercolor paper.

STEP 1B: SCENE STUDY

Use the grid overlay to conduct a scene study of the example painting. The palm trees are spread across the first, fourth and seventh blocks. Distant palm trees appear in the fifth block, hills in the seventh to ninth blocks and a palm tree trunk in the sixth block.

STEP 1C: SKETCHING

Very lightly sketch the grid and key elements of the painting on your paper—in this case, the palm trees and hills. You can erase the grid once your elements are sketched so it won't be visible in the final painting.

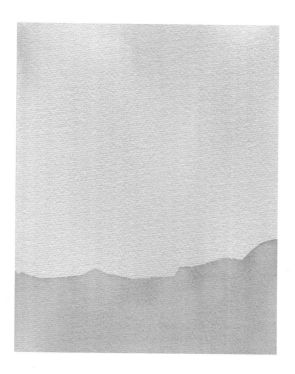

STEP 2: FLAT WASH AS BACKGROUND

Paint a flat wash using the technique of your choice, such as wet-on-dry or wet-on-wet (see pages 80 and 81). If you choose to paint wet-on-dry, use a coffee-like consistency (page 20) of Golden Deep. If you choose to paint wet-on-wet, use a milk-like consistency (page 20) of Golden Deep. Let it dry.

STEP 3: HILL

Painting a hill is like painting bushes with fewer round curves on the edges. To start, load a flat or round brush with a coffee-like consistency of Golden Deep. Paint over your hill sketch or imagine the general shape of the hill and fill it in. While the distant hill is still wet, rinse your brush and load it with a coffee-like consistency of Aureolin and add it in random areas. Let it dry.

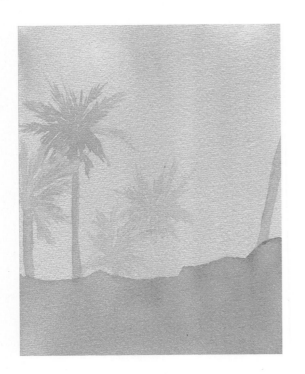

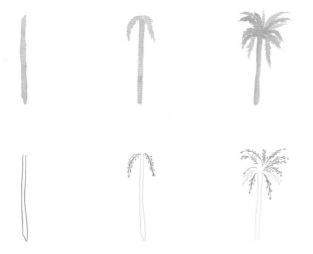

STEP 4: LOOSE PALM TREES

Once the first hill has dried, start painting palm trees.

Load your brush with a milk-like consistency of Golden Deep and use your round brush to paint the tree trunk. While it's still wet, paint the foliage of the palm trees.

Remember painting slender leaves (see page 34)? You can make palm tree foliage the same way. Alternate between using tea-like (page 20) and coffee-like consistencies of Golden Deep. Paint a branch first and then add leaves with short pointed strokes (page 32). Continue to paint multiple branches and leaves until you achieve the shape of the palm tree foliage.

STEP 5: FOREGROUND HILL

Load your brush with a milk-like consistency of Cadmium Orange and paint the foreground hill. Let it dry.

ENCHANTED FOREST

Now it's time for an enchanting moment with washes by exploring the beauty of the forest. In this project, you'll use a gradient wash to paint an enchanted forest. What I like about this project is that the steps are very simple, yet the result is undeniably amazing. If you're ready to see what I mean, let's get started!

MATERIALS

Masking or painter's tape

140lb (300gsm), 100% cotton rag, cold-pressed watercolor paper

Painting board

Pencil and eraser

Flat or hake brush (page 12)

Round brush (page 12)

COLOR PALETTE

Perylene Violet

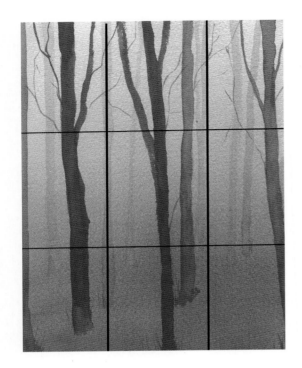

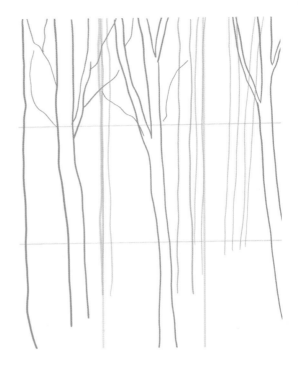

STEP 1A: PREPARATION

Prepare the materials on your painting table. Using masking or painter's tape, secure your sheet of watercolor paper to a board. This is to prevent the paper from buckling or curling. You can skip this step if you're using a block of watercolor paper.

STEP 1B: SCENE STUDY

We are going minimalist in this project, but rest assured that the end result will be breathtaking. Use the grid overlay to conduct a scene study of the example painting. This painting has one key element—the tree trunks—which are painted with different consistencies of pigment and strokes of different length and size.

STEP 1C: SKETCHING

There are three groups of trees in the painting: distant trees, middle trees and foreground trees. Sketching them is optional, but notice that the most distant trees are shorter compared to the foreground and middle trees to give the forest depth. In terms of paint consistencies, you've learned in previous projects and lessons that using less concentrated paint helps to suggest distance.

 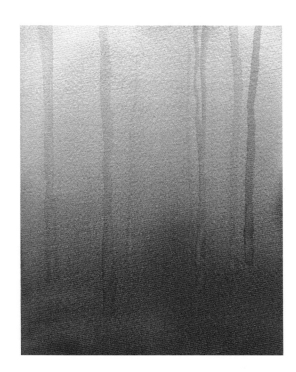

STEP 2: BACKGROUND

We will be using a gradient wash for the background (see page 79). Your gradient will transition from light to dark as you go down the page to suggest mist and fog in the distance. Feel free to choose your wash method—either wet-on-wet or wet-on-dry. Personally, I find the wet-on-wet method more comfortable. Start with a coffee-like consistency (page 20) of Perylene Violet and gradually transition to a cream-like consistency (page 20).

Let the background dry completely.

STEP 3: DISTANT TREES

Load your brush with a coffee-like consistency of Perylene Violet and paint the distant tree trunks. Let it dry.

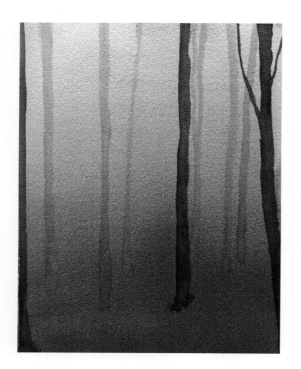 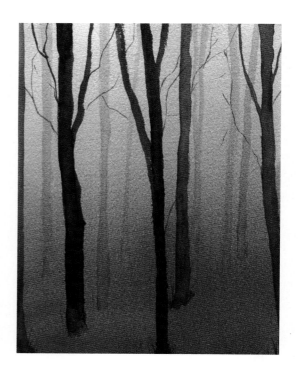

STEP 4: MIDDLE TREES

Add more paint to the coffee-like paint to make it a milk-like consistency (page 20), then paint the middle trees. Let it dry.

STEP 5: FOREGROUND TREES

Lastly, add more paint to the milk-like paint to make it a cream-like consistency, then paint the foreground trees.

ELECTRIC

In this project, we will use the third type of wash—a variegated wash—as the background to a nostalgic electric poles view. It's sure to electrify your creative juices!

MATERIALS

Masking or painter's tape

140lb (300gsm), 100% cotton rag, cold-pressed watercolor paper

Painting board

Pencil and eraser

Flat or hake brush (page 12)

Round brush (page 12)

Script brush (page 12)

COLOR PALETTE

Aureolin, Quinacridone Lilac, Quinacridone Rose and Payne's Gray

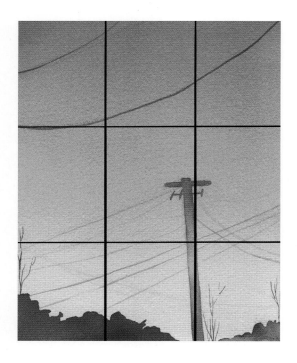

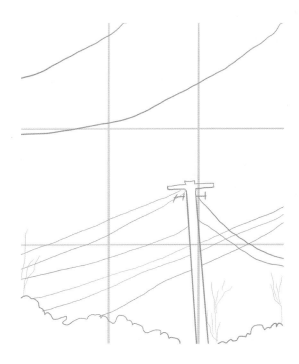

STEP 1A: PREPARATION

Prepare the materials on your painting table, including the paints you are going to use for the wash in Step 2. Since variegated wash is best done using the wet-on-wet technique (see page 81), preparing the paints in advance will help you transition smoothly between colors before your paper has a chance to dry.

Using masking or painter's tape, secure your sheet of watercolor paper to a board. This is to prevent the paper from buckling or curling. You can skip this step if you're using a block of watercolor paper.

STEP 1B: SCENE STUDY

Use the grid overlay to conduct a scene study of the example painting. Bushes and bare trees are located in the seventh through ninth blocks, and the electric pole is in the middle of the fifth, sixth, eighth and ninth blocks. Notice that there are electric wires in random places.

STEP 1C: SKETCHING

Even though sketching is optional for this project, it's helpful to know where you want to place the elements before painting. Lightly sketching a grid on your paper can also help you map the colors for the background.

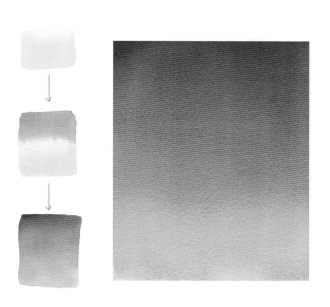

STEP 2: BACKGROUND

Use a flat or hake brush to wet the paper until it is soaked (page 72). Paint the background with a variegated wash while the paper is still soaked. Remember that if the paper reaches a damp stage, it will create unwanted texture, so work on your wash at the soaked stage until the paper reaches the moist stage. Refer to the grid, and apply a milk-like consistency (page 20) of Aureolin from the seventh to nineth blocks, a milk-like consistency of Quinacridone Lilac from the first to third blocks, and a milk-like consistency of Quinacridone Rose in the middle of the first two. Let it dry.

STEP 3: BUSHES

Load your brush with a milk-like blend of Quinacridone Lilac and a hint of Payne's Gray to paint the bushes. While it's still wet, add a milk-like consistency of Quinacridone Rose on the bigger bush and Aureolin on the smaller bush. Let it dry.

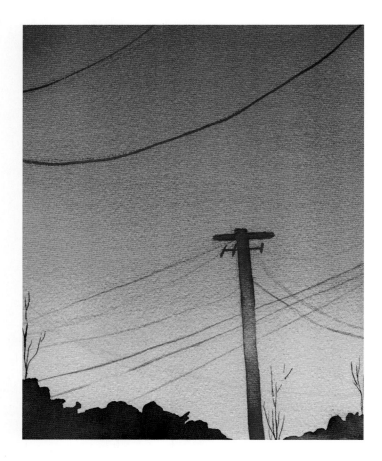

STEP 4: ELECTRIC POLE, WIRES AND THE TREES

Using your round brush, apply heavy pressure (page 28) to paint the silhouette of an electric pole, working from top to bottom with a milk-like consistency of Quinacridone Lilac. While it's still wet, add a coffee-like consistency (page 20) of Aureolin to the middle part of the pole. The two colors combined might get muddy or dull, so be careful not to mix them forcefully with your brush. Instead, let them blend and interact naturally on the paper. Let it dry.

Using a script brush or smaller round brush, apply feather to light pressure (pages 27 and 28) to paint long strokes across the paper for the electric lines. Use coffee-like consistencies of Aureolin and Quinacridone Lilac separately for the electric lines on the lower part of the paper. Use a milk-like blend of Quinacridone Lilac and a hint of Payne's Gray for the electric lines on the upper part of the paper.

Let the painting dry and add bare trees with a milk-like consistency of Payne's Gray.

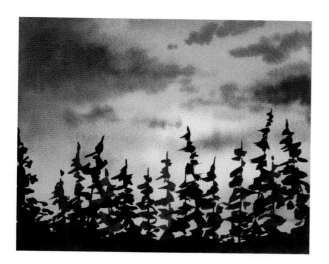

SUNSET

A sunset is such a breathtaking view. It never fails to catch everyone's attention. In this project you will learn how to present the randomness of the sky. You will also revisit painting an irregular wash as a dramatic sunset. I'm excited for you to discover the satisfaction of painting this breathtaking scene with your own hands.

MATERIALS

Masking or painter's tape

140lb (300gsm), 100% cotton rag, cold-pressed watercolor paper

Painting board

Flat or hake brush (page 12)

Round brush (page 12)

COLOR PALETTE

Aureolin, Golden Deep, Cadmium Orange, Ultramarine and Payne's Gray

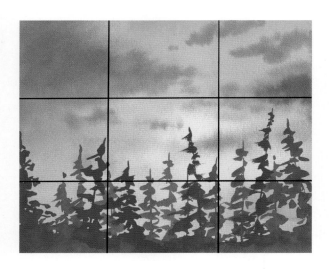

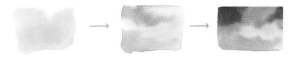

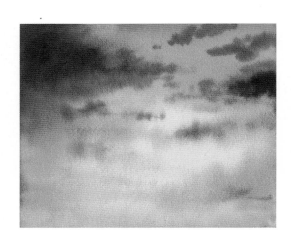

STEP 1A: PREPARATION

Prepare the materials on your painting table, including the paints you are going to use for the wash in Steps 2 and 3. Since a variegated wash is best done using the wet-on-wet technique (see page 82), preparing the paints in advance will help you transition smoothly between colors before your paper has a chance to dry.

Using masking or painter's tape, secure your sheet of watercolor paper to a board. This is to prevent the paper from buckling or curling. You can skip this step if you're using a block of watercolor paper.

STEP 1B: SCENE STUDY

This scene is very straightforward with only two key elements. The pine trees cover the fourth through ninth blocks, and the sunset sky is in the background.

STEP 2: SKY

Prepare the colors you will use as washes in separate wells in your mixing palette. Set aside milk-like consistencies (page 20) of Aureolin, Golden Deep and Cadmium Orange and a milk-like blend of Cadmium Orange and Ultramarine.

With your flat or hake brush, evenly soak (page 72) the surface of the paper, being careful not to create any puddles. Use your round brush to lay down Aureolin on most parts of the paper, then quickly rinse your brush and load it with Golden Deep to paint on the upper and lower parts of the paper. Continue with Cadmium Orange, applying it around the corners of the paper.

While the paper is still soaked, the colors will migrate and that's fine—no need to get alarmed or worried. Now you don't have to blend the colors forcefully on the paper with your brush. Let the watercolors do their magic while you rinse your brush and prepare to add dark clouds.

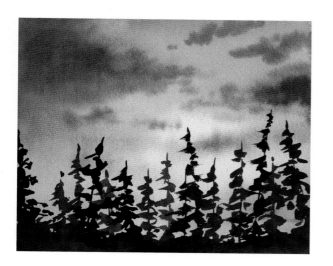

STEP 3: DARK CLOUDS

When the paper has reached the moist stage (page 72), you still have a little time to work on forming dark clouds with a milk-like blend of Cadmium Orange and Ultramarine. Quickly lay down the mixture with fast and random strokes. Let it dry.

STEP 4: PINE TREE SILHOUETTES

Now paint silhouettes of the pine trees using a milk-like to cream-like consistency (page 20) of Payne's Gray. Start with the tree trunks, applying light pressure (page 28) to make upward strokes. Then, paint the foliage with gestural marks that are similar to curve strokes (page 38). Use the tip of your brush while applying different amounts of pressure.

Let it dry.

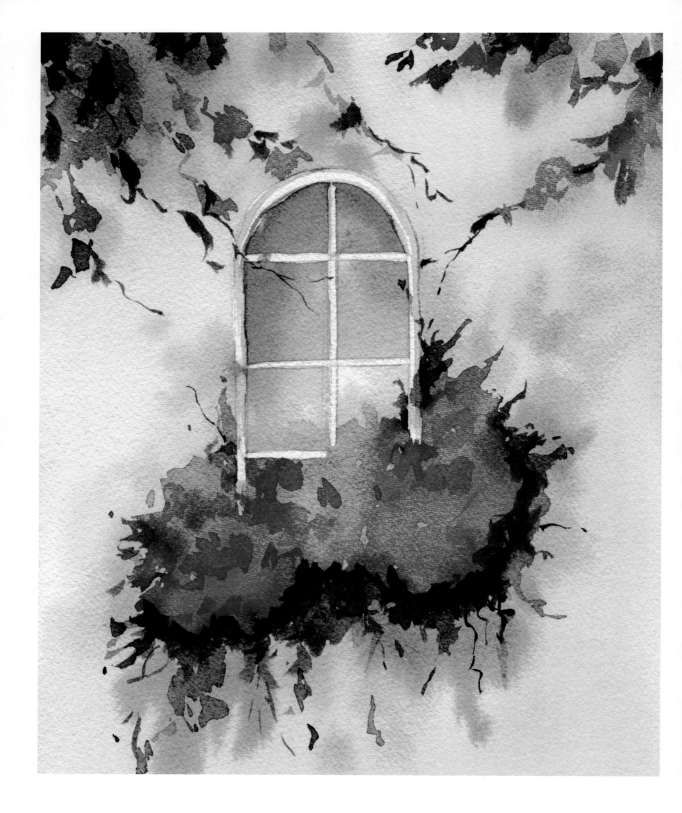

Additional Techniques

The range of existing watercolor techniques is unlimited! Once you grasp the basics and continue exploring and creating on a regular basis, you will surely develop new techniques of your own. In this chapter, we will explore techniques that provide interesting effects and enjoyable opportunities for creativity.

Value and Contrast

After painting landscapes for a few months, I looked at my finished paintings and said to myself, "The colors look good, but something is missing!" or "My brushwork looks fine, but my painting looks flat!" To progress further on my watercolor journey, I researched for weeks and ultimately flew to the Philippines to attend a private class with Drew Europeo, a seasoned, high-caliber multimedia artist with unquestionable watercolor knowledge. The things I do for passion, right? It turns out, what I was missing in my paintings was a strong understanding of value and contrast.

Value is the term used to describe the relative lightness or darkness of a color. There are three major color values in any painting—light values, middle values and dark values. Artists use values to convey depth and feeling. For instance, paintings dominated by lighter values feel more airy, distant and ethereal than a painting dominated by darker values, which are often perceived as dramatic and intense.

A typical landscape composition is arranged as light-valued background, a midground with medium values and a dark-valued foreground.

Contrast is the degree of difference between values and can fall anywhere in between white and black. Healthy contrast is important to any painting and should be used consistently.

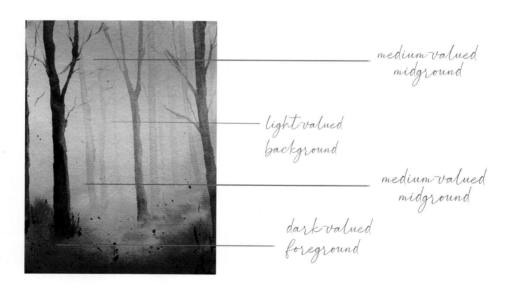

medium-valued midground

light-valued background

medium-valued midground

dark-valued foreground

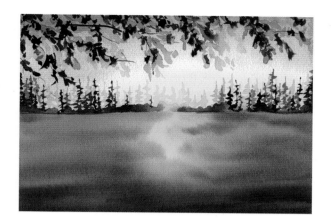

MEADOW

"The world has enough beautiful mountains and meadows, spectacular skies and serene lakes. It has enough lush forests, flowered fields and sandy beaches. It has plenty of stars and the promise of a new sunrise and sunset every day. What the world needs more of is people to appreciate and enjoy it."

—Michael Josephson

In this project, you will get to practice the application of value in your paintings. I will also introduce you to the basic concept of the horizon line.

MATERIALS

Masking or painter's tape

140lb (300gsm), 100% cotton rag, cold-pressed watercolor paper

Painting board

Pencil and eraser

Flat or hake brush (page 12)

Round brushes, size 6 or 8 and size 10 (page 12)

COLOR PALETTE

Ultramarine, Aureolin, Golden Deep, Sap Green and Sepia

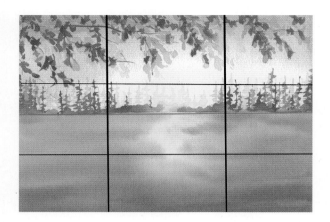

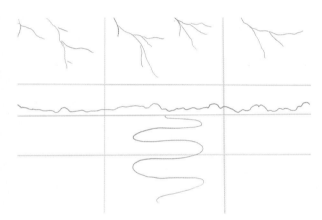

STEP 1A: PREPARATION

Prepare the materials on your painting table. Using masking or painter's tape, secure your sheet of watercolor paper to a board. This is to prevent the paper from buckling or curling. You can skip this step if you're using a block of watercolor paper.

STEP 1B: SCENE STUDY AND HORIZON LINE

In this project, you'll work with a horizon line. A horizon line is a horizontal line that runs across the paper or canvas to represent the viewer's eye level, or to delineate where the sky meets the ground. The horizon line here is marked in orange. I often establish a horizon line when I paint landscapes.

Use the grid overlay to conduct a scene study of the example painting. Locate the line that separates the meadow from the sky—the horizon line—and then place the other elements of the painting. The sky, branches and foliage will be in the first through third blocks, while the pines, bushes and meadow will be in the fourth through ninth blocks. Notice also that the light on the meadow is much more concentrated in the fifth and eighth blocks.

The sky is going to have the lightest value in the painting, and selected foliage and trees have dark value for contrast. The rest of the painting will incorporate middle values.

STEP 1C: SKETCHING

As with some of the other landscape compositions, there is no need to sketch all the vegetation, as it will be painted collectively. Refer to your scene study to lightly mark the horizon line and other key elements.

2

3A

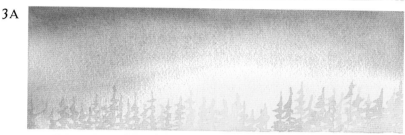

3B

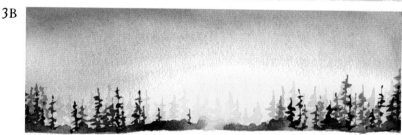

STEP 2: PAINTING SKY

Prepare coffee-like consistencies (page 20) of Ultramarine and Aureolin. Set aside while you wet the upper part of the horizon line using your flat or hake brush. When the paper is soaked, apply Ultramarine to the upper part of the sky using a size 10 round brush. Rinse your brush and apply Aureolin from the horizon line going up.

Do not blend or mix the two colors on the paper, as you don't want any shades of green in the sky for this project. Let the paper dry flat.

STEP 3A: PINES

Once the sky is dry, alternate using coffee-like consistencies of Aureolin and Golden Deep with your size 6 or 8 round brush to paint the first layer of pine trees.

Keep the shape of a pine tree in mind as you flick your brush erratically to suggest the form.

Let it dry.

STEP 3B: DARKER PINES AND BUSHES

Load your brush with a milk-like consistency (page 20) of Sap Green, then paint the bushes. On the middle part of the bushes, add a milk-like consistency of Aureolin while the Sap Green is still wet. Doing so will give the impression of light on the plants.

Then use milk-like and cream-like consistencies (page 20) of Sap Green to paint the second layer of trees. Let it dry.

STEP 4A: LIGHT ON THE MEADOW

Using a flat brush, wet the lower part of the horizon until it is soaked (page 72). Load your size 10 round brush with a coffee-like consistency of Aureolin and apply it to the lower part of the horizon.

STEP 4B: MEADOW

Load the same brush with a milk-like consistency of Sap Green and paint the lower part of the horizon as well, saving the middle part. Let the Aureolin and Sap Green blend on the paper.

4A

4B

STEP 4C: DARKER GRASS

When the paper reaches the moist stage (page 72), quickly apply a milk-like consistency of Sap Green in random areas to suggest shadows. Let it dry.

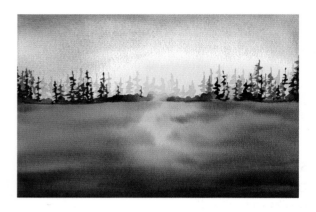

STEP 5A: BRANCHES

Prepare a milk-like blend of Sepia and Aureolin, and paint branches in the sky using a size 6 or 8 round brush.

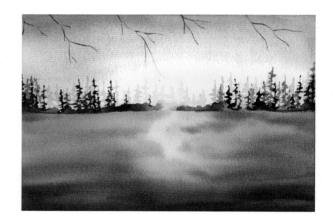

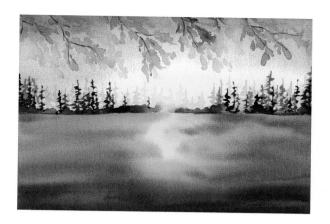 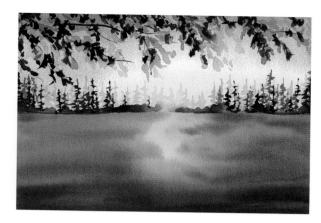

STEP 5B: FOLIAGE

Using the same brush, paint foliage on the branches with tea-like and coffee-like consistencies of Sap Green. Use the tip of your brush to make some gestural marks that suggest leaves. Apply different amounts of pressure for a more natural look. Let it dry.

STEP 5C: DARKER FOLIAGE

Using the same brush and a cream-like consistency (page 20) of Sap Green, paint darker leaves on the top of the lighter ones to add contrast. As in the previous step, use the tip of your brush to make gestural marks, applying different amounts of pressure.

White Space

White space in any painting suggests light. Learning to reserve white space in your compositions is fundamental to watercolor painting—arguably just as important as learning about color and value. White space can add contrast, impact and highlights to a painting.

If I need to save a white space on my painting, I normally work around it and try not to put any paint on the area. I use this technique a lot when I paint sky, water, snow and meadow scenes.

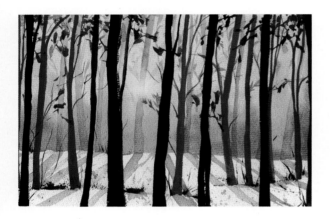

BACKLIT FOREST

This project will transport you to a place where autumn is ending, winter is about to start and golden hour is especially magical.

We will practice how to save white spaces on your paper to suggest light and snow-covered ground while working wet-on-wet and wet-on-dry. I've chosen this project because I love golden hour, and painting a backlit forest is so easy and fun!

MATERIALS

Masking or painter's tape

140lb (300gsm), 100% cotton rag, cold-pressed watercolor paper

Painting board

Pencil and eraser

Flat or hake brush (page 12)

Round brushes, sizes 6 and 10 (page 12)

Script brush (page 12)

COLOR PALETTE

Aureolin, Cadmium Orange, English Red, Burnt Sienna, Sepia and Indanthrene Blue

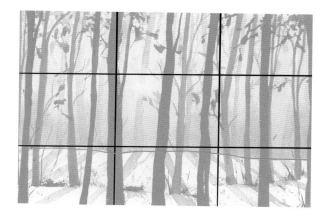

STEP 1A: PREPARATION

Prepare the materials on your painting table, including the paints you are going to use for the washes in Steps 2 and 3. You will be using the wet-on-wet technique (see page 72), so preparing the paints in advance will help you transition smoothly between colors before your paper has a chance to dry.

Using masking or painter's tape, secure your sheet of watercolor paper to a board. This is to prevent the paper from buckling or curling. You can skip this step if you're using a block of watercolor paper.

STEP 1B: SCENE STUDY

Use the grid overlay to conduct a scene study of the example painting. The source of light is located in the fifth block and some rays of light in the second block. The horizon line separates the golden colors of the sky and background from the snow-covered ground, providing powerful contrast to the painting.

In the picture above, there are tree trunks all over the painting. These trees are divided into three categories: distant trees, middle trees and foreground trees. The lines in the lower part of the seventh through ninth blocks will help create the illusion of uneven ground later on.

STEP 1C: SKETCHING

As tempting as it may be to sketch every element of the painting, resisting the urge to do so will help you avoid confusion in this project and give you more freedom to paint trees later on.

Lightly sketch the horizon line and an oval shape marking your source of light. Also sketch the horizontal lines indicating where your middle trees will be located. Later on, these lines will also help suggest uneven ground.

 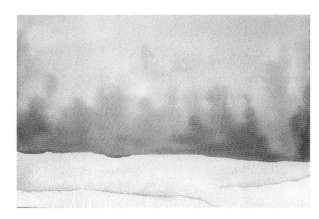

STEP 2: SAVING WHITE

The general idea is to save the white area inside the oval shape you sketched, as that will be the source of light in this project.

Start by wetting the surface of the paper using your flat brush or hake. Once the paper is soaked (page 72), load your size 10 round brush with a milk-like consistency (page 20) of Aureolin and carefully paint outside the oval shape. Gradually lessen the concentration of the pigment as you move away from the oval shape. You only want a hint of Aureolin on the lower part of the horizon—just enough color to paint the light on the snow-covered ground.

Quickly rinse your round brush and load it with a coffee-like consistency (page 20) of Cadmium Orange. Now paint around the Aureolin until the upper part of the horizon line is covered. You only want a hint of Aureolin on the lower part of the horizon line, so try not to paint in that area with Cadmium Orange. Keep in mind that when the paper is soaked, any paint that's applied to it will continue to be in motion until it starts to dry. Try not to tilt your paper, and keep an eye on the oval-shaped area you are protecting from paint. Let the paper dry.

STEP 3: SILHOUETTE BUSHES

Re-wet the area above the horizon line, wait for the paper to reach the moist stage (page 72), then load your size 10 round brush with a milk-like consistency of English Red. Start painting the silhouette of background bushes across the top of the horizon line while avoiding the source of the light. Let it dry.

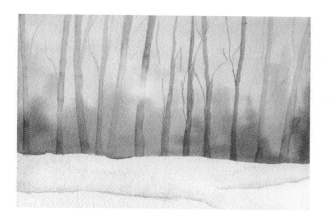

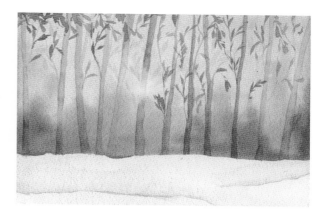

STEP 4: DISTANT TREE TRUNKS AND FOLIAGE

Prepare coffee-like and tea-like consistencies (page 20) of English Red. Once the paint you applied in Step 3 is completely dry, use a size 6 round brush to paint tree trunks across the paper, covering the first through sixth blocks and alternating both consistencies of English Red.

Add a coffee-like consistency of Aureolin to the tree trunk that overlaps the light source and the one beside it. Doing so will give the impression of light passing through the distant tree trunks.

While waiting for the distant tree trunks and foliage to dry, load your brush with a coffee-like consistency of English Red. Use light pressure (page 28) to paint a line below the horizon in the seventh and eighth blocks. This is going to be the slightly elevated ground. Let it dry.

Prepare coffee-like consistencies of Aureolin and English Red. Load your size 6 round brush and paint foliage using the tip of the brush. Paint small pointed leaves (see page 32). Allow the Aureolin color to be more concentrated near the source of light.

Rinse your brush and load it with a coffee-like consistency of English Red. Paint foliage across the trees on the upper part of the paper. Be careful not to paint on the source of the light. Let it dry.

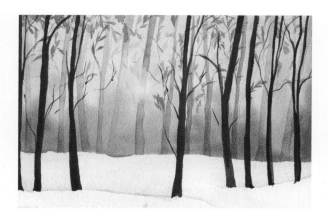 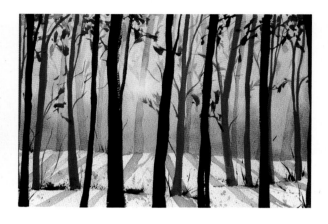

STEP 5: MIDDLE TREES

Load your size 6 round brush with a cream-like consistency (page 20) of Burnt Sienna. Paint eight tree trunks, working from the top of the paper to the elevated ground. Once you're finished, load your script brush with the same consistency of paint and paint some branches from the middle tree trunks. Let it dry.

STEP 6: FOREGROUND TREES AND SHADOWS

Load your size 6 round brush with a cream-like consistency of Sepia. Paint tree trunks, making strokes from the top of the paper to the bottom. Using the same brush, paint some foliage as well. Let it dry.

Rinse the brush and load it with a coffee-like consistency of Indanthrene Blue. Paint some shadows of tree trunks on the snow-covered ground.

Lifting and Tissue Blotting

These two techniques refer to the process of removing paint after it has been applied to the paper. I normally use them to create interesting effects with a brush or a tissue. Here are visual representations to help you compare the two.

LIFTING

With a clean, damp brush, make several strokes on the surface of the painting where you want to lift some pigments off. Repeatedly rinse your brush to remove more paints on the surface of the paper.

TISSUE BLOTTING

Tissue blotting is an easy way to lighten the value of an area you just painted. It can also add texture to your painting. I normally use this technique when creating clouds.

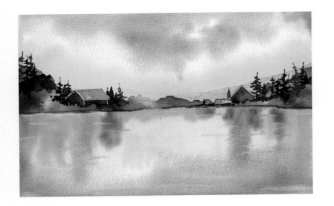

LAKE HOUSE

Lake houses are one of my most favorite subjects of all time! I've never been to one, but I often picture myself in a lake house, enjoying coffee in the morning as I wait for the sun to rise and shower the lake with its light. Daydream with me as we create our very own lake house.

In this project you will experiment with lifting pigment to create interesting effects as you paint a watery reflection. Sound fun? Let's do this!

MATERIALS

Masking or painter's tape

140lb (300gsm), 100% cotton rag, cold-pressed watercolor paper

Painting board

Pencil and eraser

Flat brush (page 12)

Round brushes, sizes 6, 8 and 10 (page 12)

COLOR PALETTE

Aureolin, Ultramarine, Cadmium Orange and Sap Green

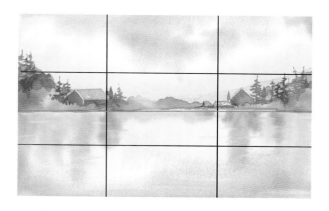

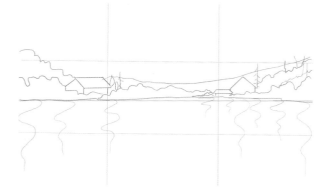

STEP 1A: PREPARATION

Prepare the materials on your painting table. Using masking or painter's tape, secure your sheet of watercolor paper to a board. This is to prevent the paper from buckling or curling. You can skip this step if you're using a block of watercolor paper.

STEP 1B: SCENE STUDY

Before starting, take time to locate the horizon line and the key elements in this project to refrain from getting overwhelmed.

The sky occupies the first through third blocks, vegetation and houses occupy the fourth through sixth blocks and the lake with reflection occupies part of the fourth through sixth blocks and the entire seventh through ninth.

STEP 1C: SKETCHING

Lightly sketch the grid onto your blank paper. Next, establish your horizon line and sketch the other elements of the project using the guide above.

You can erase the grid before you wet the paper so it won't show in the final painting. Personally, I don't mind my sketches being visible—especially when I'm making a study piece. But it is completely okay to lighten the sketches for a much cleaner look.

STEP 2: SKY

Use a flat brush to pre-wet the upper part of the horizon, excluding the houses. Load your size 10 round brush with a coffee-like consistency (page 20) of Aureolin. Apply the paint just above the horizon line, including to the vegetation and half of the sky. This is to suggest sunrise.

Quickly rinse your brush completely and load it with a coffee-like consistency of Ultramarine. Apply it to the upper part of the paper, saving some white areas in the middle of Ultramarine and Aureolin, and tilt it a little bit for a couple of seconds to encourage the pigment to flow downward. Let it dry.

STEP 3: DISTANT MOUNTAIN

Load your size 8 round brush with a coffee-like blend of Ultramarine and Cadmium Orange and paint a distant mountain at the back of the house on the right. Use your sketch as a guide to paint the shape of the mountain. Because it is distant, you do not have to paint details.

Let it dry.

STEP 4: VEGETATION

Prepare a milk-like consistency (page 20) of Aureolin and Sap Green and a milk-like blend of Sap Green and Ultramarine.

Using a size 8 round brush, paint the vegetation above the horizon line with Sap Green. While it is still wet, add Aureolin to some areas and the blend of Sap Green and Ultramarine to other areas. Let it dry.

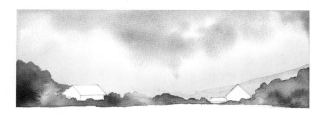

STEP 5: LAKE HOUSES

Prepare coffee-like and milk-like consistencies of both Ultramarine and Cadmium Orange separately.

Using a size 6 round brush, paint the roof of the smaller house first with a milk-like consistency of Cadmium Orange. Make sure to leave gaps or white spaces on the roof. Then paint the roof of the house on the left side with a coffee-like consistency of Ultramarine on the top and a coffee-like consistency of Cadmium Orange on the bottom.

Paint the houses with a milk-like consistency of Ultramarine. Add a milk-like consistency of Cadmium Orange to the bottom part of the big house on the right side of the page.

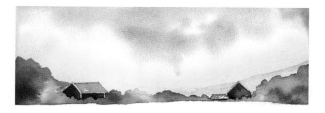

6

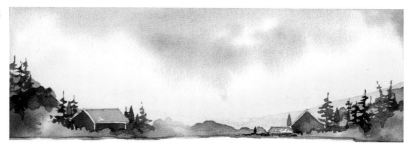

7

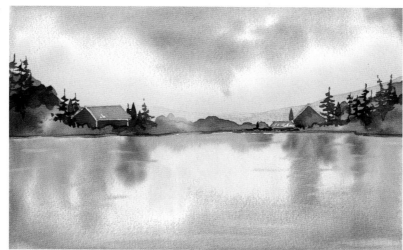

STEP 6: DARK PINES

Load your size 6 round brush with a cream-like consistency (page 20) of Sap Green and paint darker trees on random areas. Start with the tree trunks and then paint the foliage with gestural marks similar to curve strokes (page 38). Use the tip of your brush while applying different amounts of pressure.

Below the horizon line, apply semi-heavy pressure (page 28) to extend the vegetation with a milk-like consistency of Sap Green. This extension will help separate the vegetation and the lake reflection later on. Let it dry.

STEP 7A: LAKE

Use a flat brush to pre-wet the area below the horizon line where the lake will be. Load your size 10 round brush with a milk-like consistency of Ultramarine and apply a gradient wash, starting at the bottom of the paper and working toward the horizon line (see page 81).

STEP 7B: REFLECTION

After completing the gradient wash, tilt the paper and add coffee-like consistencies of all the colors to the upper part of the horizon line to suggest reflections in the water of all the elements: Sap Green to reflect the vegetation, Aureolin to reflect the light or sunshine and Ultramarine and Cadmium Orange to reflect the houses.

Let gravity take over for a while and lay the paper flat when you are satisfied with the reflections you've created.

STEP 7C: REFLECTION HIGHLIGHTS

Using the lifting techniques described on page 111, lift some paints on random areas of the reflections and the lake to create a more interesting water effect.

Watercolor Texture and Special Effects

We generally think of texture as something we can feel, but there are several ways to visually suggest it on a flat surface with watercolors. Adding visual texture makes paintings come alive. They are more convincing and much more interesting to the viewer.

In this section, I will introduce simple techniques to create or suggest textures with watercolors.

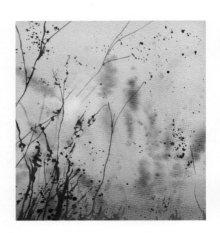

SPLATTERING

Splattering is the technique I use the most to achieve texture. It's easy and it's fun! You can use a toothbrush or just a paintbrush, and splattering can be done on both a wet surface—preferably moist (page 72)—or a dry surface. You can do this technique with paint, gouache or just plain water.

To make splatters on a wet surface, choose any color for your wash and wait until the paper reaches the damp stage (page 72), then load your brush with a cream-like consistency (page 20) of paint in any color and tap the brush over the paper to produce splatters.

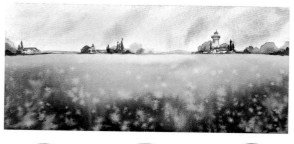

BLOOMS

Lay down a wash in any color with a flat brush or mop brush. For best results, wait until the paper reaches the damp stage, then load your brush with just water and tap the brush over your paper. Alternatively, you can carefully drop water on the area where you want to create blooms using your brush.

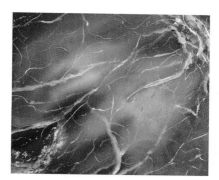

GOUACHE

Gouache is basically another form of watercolor; the difference is that gouache is characterized by its opacity. Because of this characteristic, gouache is often used with watercolors to create highlights.

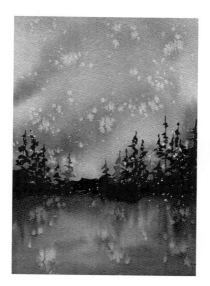

SALT ON DAMP WASH

Lay down a wash in any color with a flat brush or mop brush, then sprinkle salt onto the area where you wish to create the texture. Wait for the paper to completely dry, then brush the salt off.

The texture produced by this technique depends on the type of salt you use and how wet the wash on the paper is. Ideally, wait for your paper to reach a damp stage to maximize the effect of the salt. Larger salt crystals will create larger white areas, and the dryer the wash, the lighter the texture will be. But don't let the paper get too dry, or it won't show up at all.

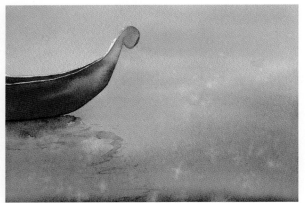

SUN GLITTER

How amazing is the feeling of warm sunshine streaming down on you? How mesmerizing is it to watch the sea and bathe in it too? Ha! That rhymes!

In this project, we will take an imaginary journey to a seaport and learn how to make sunlight appear to glitter on a body of water using watercolor blooms (page 117).

MATERIALS

Masking or painter's tape

140lb (300gsm), 100% cotton rag, cold-pressed watercolor paper

Painting board

Pencil and eraser

Flat or mop brush (page 12)

Round brushes, sizes 4 or 6, 8 and 10 (page 12)

Tissue or cloth

COLOR PALETTE

Aureolin, Emerald Green, Turquoise Blue, Indigo and Indanthrene Blue

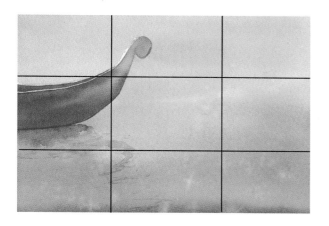

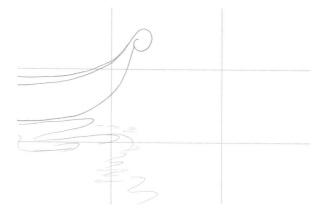

STEP 1A: PREPARATION

Prepare the materials on your painting table, including the paints you are going to use for the wash throughout Step 2. Be sure to prepare enough to cover the whole page. You will be using the wet-on-wet technique (see page 72), so preparing the paints in advance will help you transition smoothly between colors before your paper has a chance to dry.

Using masking or painter's tape, secure your sheet of watercolor paper to a board. This is to prevent the paper from buckling or curling. You can skip this step if you're using a block of watercolor paper.

STEP 1B: SCENE STUDY

Use the grid overlay to conduct a scene study of the example painting and locate the elements of the project. This project is pretty straightforward, with the bow of the boat being the most prominent feature in the first, second, fourth and fifth blocks.

STEP 1C: SKETCHING

Lightly sketch the boat in the upper left of the page. Use the guide above for reference.

STEP 2A: WATER

Use your flat brush or mop brush to wet the surface of the paper, excluding the boat. On the middle part of the page, apply a coffee-like consistency (page 20) of Aureolin with a size 10 round brush.

STEP 2B: WATER

Rinse your brush quickly and load it with a milk-like consistency (page 20) of Emerald Green. Apply it on a random part of the page, covering some part of the Aureolin. Remember to keep it simple and do not overwork the water at this stage.

Rinse your brush and load it with a milk-like consistency of Turquoise Blue. Apply it to random places on the page, then let the three colors blend together while you load your brush with a milk-like consistency of Indigo for the next step.

STEP 2C: WATER

When the paper has reached the moist stage, apply Indigo on the bottom part of the page.

STEP 2D: SUN GLITTER

Load your size 4 or 6 round brush with just clean water. Make sure that the brush is not too full of water or it will explode on the surface of the wet paper. You only want small blooms, so you need to load the brush with just enough water. Carefully splatter water on random areas of the lower part of the page to create blooms. Once done, load the same brush with a cream-like consistency (page 20) of Aureolin and splatter it on the lower part of the page as well.

Quickly rinse your brush and use a tissue or cloth to lift some blooms that were created by the water splatter. This technique will create the appearance of a gleam or glitter on the water.

2A

2B

2C

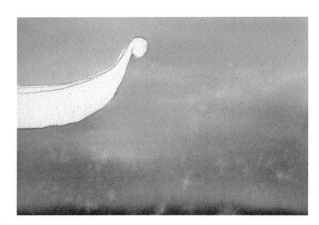

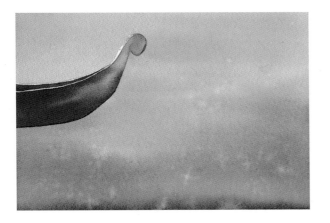

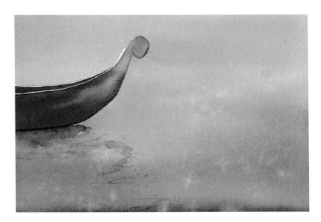

STEP 3: BOAT

Make sure the paper is completely dry before you apply paint to the boat.

Prepare milk-like consistencies of Indanthrene Blue and Turquoise Blue and do a variegated wash (see page 82) on the body of the boat using a size 8 round brush. Let it dry.

STEP 4: SHADOW

When the paper is dry, load your size 8 round brush with a milk-like consistency of Indigo to paint the shadow of the boat directly below it.

Resist Technique

The resist technique involves protecting areas of your painting by covering it with tools like masking tape or masking fluid. Then you can paint over the masked area without disturbing the protected space underneath. I personally do not use a lot of masking fluid, but it is a very important technique to get familiar with because it comes in handy when you want to preserve a very small area on your page that isn't practical to cover with tape.

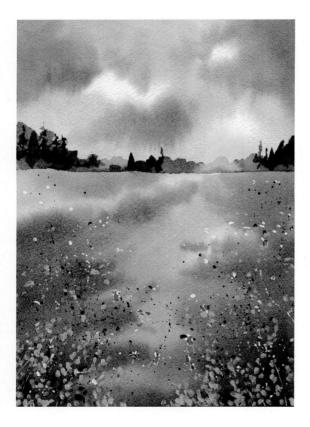

SUNLIT FLOWER FIELD

In this project, you will learn how to use masking fluid to preserve an area on your paper while you are painting. You will also use gouache (page 117) to paint flowers. Combining these techniques with the others you've learned so far can result in interesting effects. Are you ready to experiment?

MATERIALS

Masking or painter's tape
140lb (300gsm), 100% cotton rag, cold-pressed watercolor paper
Painting board
Pencil and eraser
Round brush with synthetic bristles (pages 12 and 13)
Masking fluid
Flat brush (page 12)
Round brushes, sizes 8 and 10 (page 12)

COLOR PALETTE

Ultramarine, Aureolin, Golden Deep, Indigo, Sap Green, Ruby and Permanent Yellow Orange

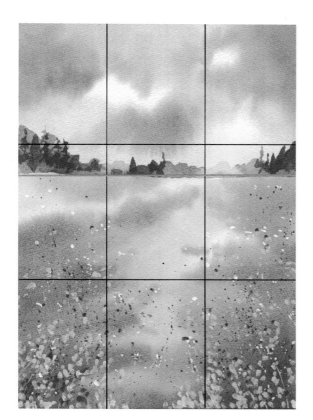

STEP 1A: PREPARATION

Prepare the materials on your painting table, including the paints you are going to use for the washes in Steps 2 and 4. You will be using the wet-on-wet technique (see page 72), so preparing the paints in advance will help you transition smoothly between colors before your paper has a chance to dry.

Using masking or painter's tape, secure your sheet of watercolor paper to a board. This is to prevent the paper from buckling or curling. You can skip this step if you're using a block of watercolor paper.

STEP 1B: SCENE STUDY

Use the grid overlay to conduct a scene study of the example painting. Locate the horizon line and the elements of the painting. The sky is in the first through third blocks, the vegetation is on the upper side of the fourth through sixth blocks, the field stretches from the fourth through ninth blocks and the flowers are concentrated more on the seventh through ninth blocks with some also appearing in the third through sixth blocks.

Notice that the sunlight on the meadow travels from the upper part of the sixth block to the fifth and eighth blocks. There's light on the fourth block as well.

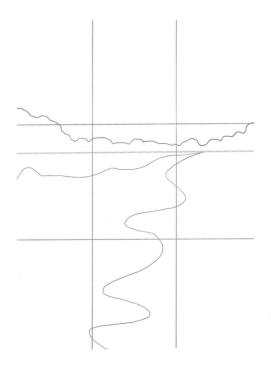

STEP 1C: SKETCHING

Lightly sketch the grid onto your paper and mark the horizon line. Next, lightly sketch the general shape of the elements in this project.

STEP 1D: MASKING

Load an old synthetic round brush that you do not use anymore with masking fluid. Cover the upper horizon line with paper or a tissue to make sure it will remain masking fluid free as you tap your brush over the paper to create a random splatter that is bigger in the lower part of the horizon and smaller on the middle part of the page. Let it dry completely.

STEP 2A: SKY

Prepare coffee-like consistencies (page 20) of Ultramarine, Aureolin and Golden Deep in separate wells of your mixing palette. Set aside.

With a flat brush, pre-wet the upper part of the horizon and load your size 10 round brush with Aureolin. Apply the paint just above the horizon line, and then add in some Golden Deep. This is where the light on the meadow will come from.

STEP 2B: SKY

Quickly rinse your brush completely and load it with Ultramarine. Apply it to the upper part of the paper. Save some white areas and tilt the paper a little bit for a couple of seconds to encourage the pigment to flow downward. Rinse your brush completely.

2A 2B

STEP 2C: SKY

Prepare a milk-like blend (page 20) of Ultramarine and Indigo. Load the same size 10 round brush and apply the mixture to the upper left, upper right and lower middle parts of the sky.

Let it dry.

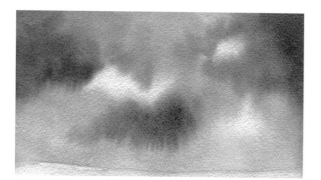

STEP 3: VEGETATION

Prepare milk-like consistencies of Golden Deep and Sap Green and a milk-like blend of Sap Green and Ultramarine.

Paint the vegetation above the horizon line with Sap Green first, then add the Golden Deep just below the light in the sky. Then, while the vegetation is still wet, add the blend of Sap Green and Ultramarine in random areas.

Let it dry and then paint trees with a cream-like consistency (page 20) of Sap Green and Ultramarine. As with any other loose watercolor trees, focus on capturing their general shape.

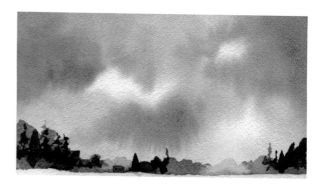

STEP 4A: LIGHT ON THE MEADOW

Using a flat brush, pre-wet the lower part of the horizon with just water. Then load your size 10 round brush with a coffee-like consistency of Aureolin and apply it to the lower part of the horizon line while the paper is soaked.

STEP 4B: GRASS

Load the same brush with a milk-like consistency of Sap Green. Keep in mind where the light travels and work around that area. Let the Aureolin and Sap Green blend on the paper.

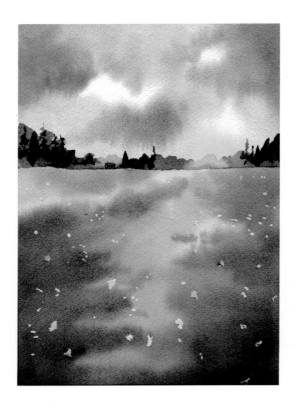

4A 4B

STEP 4C: DARKER GRASS

When the paper reaches the moist stage (page 72), apply a milk-like consistency of Sap Green in random areas to suggest shadows. Do it quickly and let it dry.

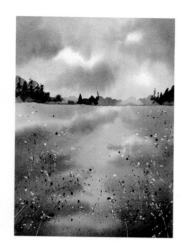

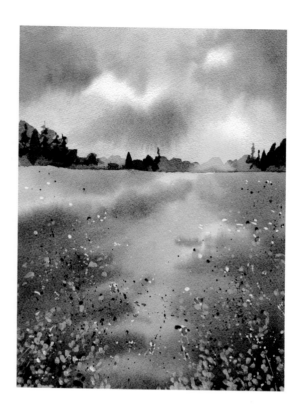

STEP 5A: FLOWERS

When the flower field is dry, carefully take off the masking fluid using an eraser or your finger. Once done, cover the sky and vegetation with paper or a tissue and load your round brush with a cream-like consistency of Sap Green. Splatter some paints on the field (see page 116). Concentrate more on the lower side.

Take your size 8 round brush and load it with a cream-like consistency of Ruby. Apply the paint on several preserved areas that were protected by the masking fluid. Concentrate more on the lower area of the paper, and to make it more interesting, try not to cover the entire white space—just cover part of it so that hints of white are still visible.

STEP 5B: GOUACHE

Load your brush with the Permanent Yellow Orange gouache (you can use a different floral color if you'd like) and stipple some paint on the field, with a high concentration on the lower part of the page, to suggest flowers. Make the lower flowers bigger than the ones in the middle part to suggest distance. Let it dry.

Positive and Negative Spaces

Every scene in a painting is made up of both positive and negative spaces. Positive space refers to the subject itself or where the subject is positioned. Negative space refers to the area around and in between the subject. Generally, we want to invite attention to our positive space and use the negative space as background. Side by side, both types of space enhance the visual experience of the viewer.

NEGATIVE PAINTING

Negative painting is a technique that involves painting around a subject rather than painting the subject itself. Usually, light washes are applied and darker colors are added around the subject to bring it into the foreground. It's useful to add shaded areas, giving depth to the painting.

AUTUMN LEAVES

For many years I avoided negative painting because I was intimidated by its complex appearance, but it was worth it to let go of the fear and finally step out of my comfort zone to try new techniques like this one.

We will focus on negative painting in this project and explore how to define a subject by painting around it.

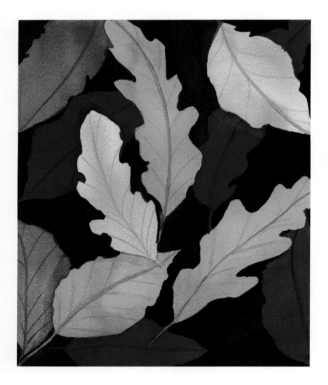

MATERIALS

Masking or painter's tape
140lb (300gsm), 100% cotton rag, cold-pressed watercolor paper
Painting board
Pencil and eraser
Flat or mop brush (page 12)
Round brush (page 12)

COLOR PALETTE

Aureolin, Cadmium Orange, English Red, Sepia and Golden Deep

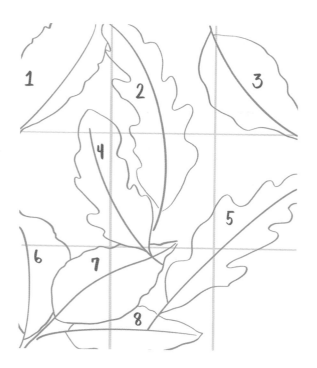

STEP 1A: PREPARATION

Prepare the materials on your painting table, including the paints you are going to use for the wash in Step 2. You will be using the wet-on-wet technique (see page 72), so preparing the paints in advance will help you transition smoothly between colors before your paper has a chance to dry.

Using masking or painter's tape, secure your sheet of watercolor paper to a board. This is to prevent the paper from buckling or curling. You can skip this step if you're using a block of watercolor paper.

STEP 1B: SKETCHING

Use the guide above to sketch autumn leaves. For guide purposes, I assigned a number to each leaf.

STEP 2: WET-ON-WET WASH

Prepare milk-like consistencies (page 20) of both Aureolin and Cadmium Orange. With a flat or mop brush, pre-wet the whole page until it reaches the soaked stage (page 72). With your round brush, add the two colors of prepared paint to the paper and allow them to interact. Let it dry.

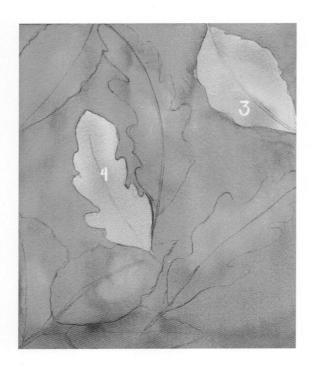

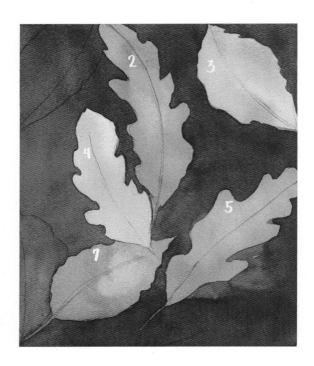

STEP 3: FIRST LAYER

Prepare enough Cadmium Orange in a milk-like consistency to cover the surface of the page. Load your round brush with it and apply a flat wash to the whole page, except leaves number 3 and 4. Let it dry.

STEP 4: SECOND LAYER

Load your round brush with a milk-like blend of Cadmium Orange and English Red, and apply a flat wash, except for leaves number 2 through 5 and leaf number 7. The key here is to make your current layers darker than the previous layer. Let it dry.

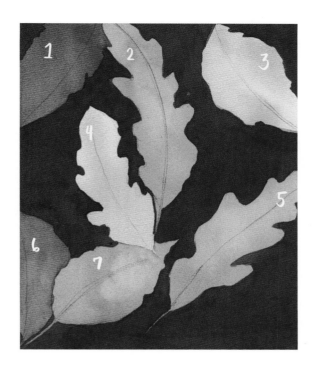

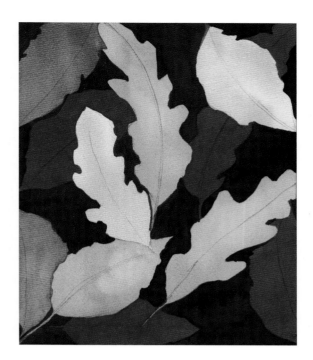

STEP 5: THIRD LAYER

Load your round brush with a milk-like consistency of English Red and apply a flat wash to the dried paper, except for leaves number 1 through 7. Let it dry. Using a pencil, trace leaf number 8 again, plus some new leaves to fill in the gaps. As the paints get darker, you can lose the visibility of the pencil lines, so you might need to sketch them twice as you prepare for the final layer.

STEP 6: FOURTH LAYER

Load your round brush with cream-like consistencies (page 20) of English Red and Sepia and paint on everything around the leaves. Let it dry.

STEP 7: DETAILS

Add leaf veins on leaves 2 to 7 with a milk-like consistency of Golden Deep. Let it dry.

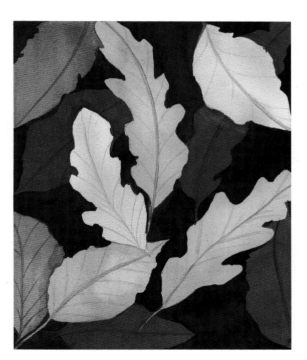

Layering and Glazing

Layering and glazing are basically the same process. They change the value of colors and direct the viewer's eyes. Glazing uses very thin, transparent washes of one color over another color. Glazing with a warm transparent color creates a luminous, glowing glaze. Applying a cool transparent color gives a heavier, denser glaze. Use glazing as a means to unify a painting, add mood or change areas of color.

Use layering to apply premixed colors over another wash to change the values or intensity, or to direct the viewer's eyes through value placement.

DREAMY PHUKET

Phuket is one of my favorite places in the Philippines! To make this dreamy landscape, you will use the glazing technique to tone down the saturation of paints that have already been applied and dried on the paper. Now, let's fly to Phuket while exploring glazing and layering techniques!

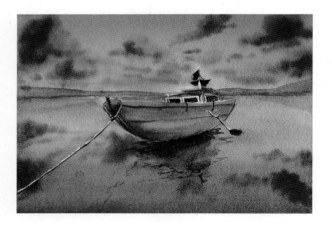

MATERIALS

Masking or painter's tape
140lb (300gsm), 100% cotton rag, cold-pressed watercolor paper
Painting board
Pencil and eraser
Synthetic round brush
Masking fluid
Flat brush (page 12)
Round brushes, sizes 8 and 10 (page 12)

COLOR PALETTE

Aureolin, Bright Blue, Quinacridone Rose, Indanthrene Blue and Indigo

STEP 1A: PREPARATION

Prepare the materials on your painting table, including the paints you are going to use for the washes in Steps 2 and 3. You will be using the wet-on-wet technique (see page 72), so preparing the paints in advance will help you transition smoothly between colors before your paper has a chance to dry.

Using masking or painter's tape, secure your sheet of watercolor paper to a board. This is to prevent the paper from buckling or curling. You can skip this step if you're using a block of watercolor paper.

STEP 1B: SCENE STUDY

Use the grid overlay to conduct a scene study of the example painting. In this project, the sky reflects on the sea, and the main boat is the primary element. The sky is in the first through third blocks, the mountain is in the upper part of the fourth through sixth blocks, the boat is in the fifth block, and the sea covers the fourth through ninth blocks.

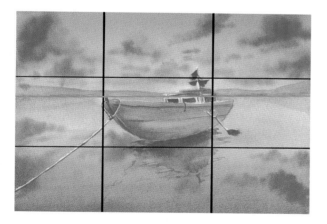

STEP 1C: SKETCHING

Lightly sketch the grid onto your paper and draw the horizon line, mountain and boat. Once you're done, use an old synthetic round brush to put masking fluid on the rope and flag of the boat (see page 124).

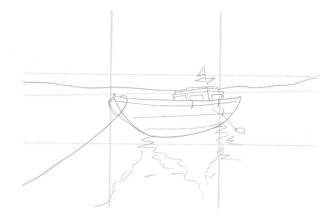

STEP 2A: SKY

Prepare milk-like consistencies (page 20) of Aureolin, Bright Blue and Quinacridone Rose separately, then pre-wet the upper part of the paper where you will paint the sky. Once the paper has reached the soaked stage (page 72), do a variegated wash (see page 82).

Start by loading your size 10 round brush with Aureolin and paint the bottom part of the page. Rinse your brush quickly and load it with Bright Blue to paint the top part of the page. Quickly rinse your brush again and load it with Quinacridone Rose and paint the middle part of the page, allowing it to blend with both Bright Blue and Aureolin.

STEP 2B: DARK CLOUDS

When the paper has reached the moist stage (page 72), load your size 8 round brush with a cream-like blend (page 20) of Quinacridone Rose and Bright Blue. Paint a dark cloud on the paper, and then a bigger and darker cloud at the top of the sky. Make it smaller and paler as it approaches the horizon line. This will give the impression of distance. Let it dry.

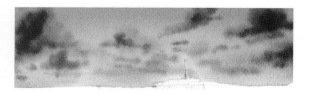

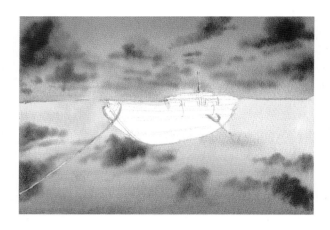

STEP 3: SKY REFLECTION ON THE SEA

Repeat Steps 2A and 2B to create the reflection of the sky on the lower part of the horizon line. Make a variegated wash with Aureolin near the horizon line and Bright Blue on the bottom part of the paper. The dark clouds should appear bigger and darker at the bottom of the page. Let it dry.

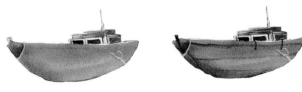

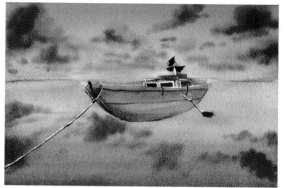

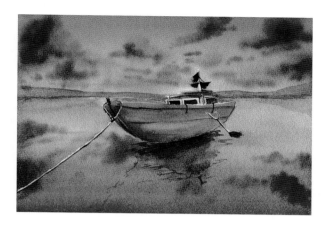

STEP 4: BOAT AND THE GLAZE

When the paper is completely dry, load your size 8 round brush with a coffee-like consistency (page 20) of Indanthrene Blue. Paint a flat wash on the boat (see page 80). Once done, rinse your brush and load it with a milk-like consistency of Indigo to paint the windows and add details. Let it dry completely.

Prepare a coffee-like consistency of Quinacridone Rose and load your flat brush or size 10 round brush. Paint another thin layer on the top of the sea. This will change the intensity of the color and tone it down. Let it dry.

Once dried, use your fingers or an eraser to gently remove the masking fluid. Then, load your brush with a milk-like consistency of Indigo and apply it to the lower part of the rope, leaving the upper part bare white. Once done, make a curve stroke (page 38) with the tip of your brush to paint the flag using the same consistency of Indigo.

STEP 5: MOUNTAIN AND SHADOW

Make sure the paper is completely dry before you proceed with painting the mountain and the shadow of the boat.

Load your size 8 round brush with a coffee-like blend of Quinacridone Rose with a hint of Indigo and paint the outline of the mountain. Rinse your brush and load it with a milk-like consistency of Indanthrene Blue and paint the shadow of the boat. Let it dry.

Storytelling through Watercolor

Now that you are acquainted and equipped with all the basics, it is time to tell your story through watercolor painting.

I believe that stories play a vital role in every creation across all mediums. An artist's interpretation of reality, their emotions and their imagination are all attached to stories that are reflected in their masterpieces. Stories are the key ingredients that unify all the techniques and all the brushmarks during the creative process. You will find your very own style as a painter the moment you tell your story through your painting. The story doesn't have to be dramatic or poetic—what is important is that it is your own narrative.

So, in an attempt to encourage you to establish your own artistic voice and a stronger connection between you and your artwork, let me share the stories behind a few of my paintings while I guide you in creating your own versions. In this chapter, we will go beyond tradition and explore something deeper.

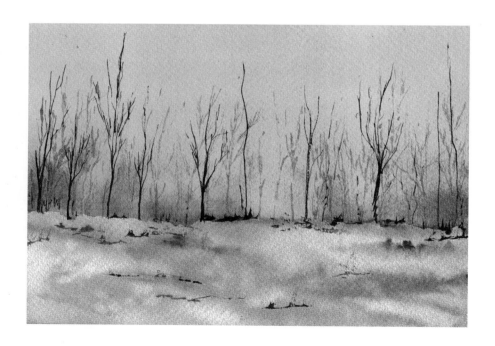

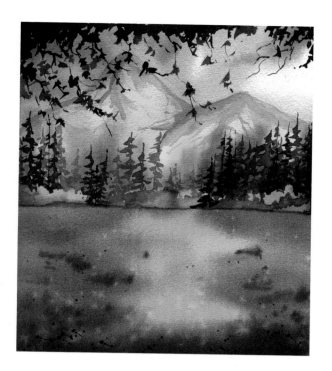

SHORTCUT TO TIRANO

One afternoon, my best friends and I were waiting for our train at Gare du Nord. It was our last day in Paris, and we were excited to see and visit Milan, but we realized that all the announcements were in French and we could not understand a thing. Long story short, we missed the train going to Milan and had to take a plane. We spent a night in Orly without a heater, and I caught the flu. Then, the moment we arrived in Milan, I realized that my cash had been stolen. Euros, dollars and pounds—all gone!

Our misfortunes didn't end there. The next morning, my alarm went off and I realized that we were late for our trip to Switzerland! We sprinted like we never had in our whole lives, and we made it to the bus. On the way to Switzerland, we stopped in a town called Tirano. Our bus parked a little too far from the cathedral and coffee shops, so we had to walk there. I don't know how we did it, but it was the best not-so-shortcut I ever took. The sky was so blue and the trees were so green. There was a beautiful snow-capped mountain and a field soaked in sunshine. Despite all our mishaps, I instantly felt grateful again.

MATERIALS

Masking or painter's tape

140lb (300gsm), 100% cotton rag, cold-pressed watercolor paper

Painting board

Pencil and eraser

Flat brush (page 12)

Round brushes, sizes 4 or 6 and 8 (page 12)

COLOR PALETTE

Ultramarine, Golden Deep and Sap Green

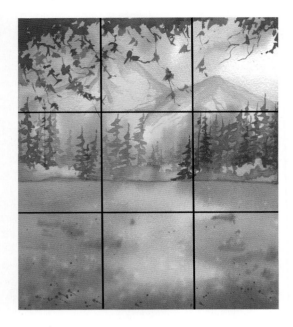

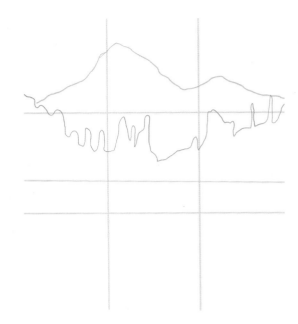

STEP 1A: PREPARATION

Prepare the materials on your painting table, including the paints you are going to use for the washes in Steps 2, 4 and 5. You will be using the wet-on-wet technique (see page 72), so preparing the paints in advance will help you transition smoothly between colors before your paper has a chance to dry.

Using masking or painter's tape, secure your sheet of watercolor paper to a board. This is to prevent the paper from buckling or curling. You can skip this step if you're using a block of watercolor paper.

STEP 1B: SCENE STUDY

Use the grid overlay to conduct a scene study of the example painting. Locate the horizon line and the main elements of the project. The sky, mountain and leaves are located in the first through third blocks. The rest of the vegetation is in the fourth through sixth blocks, and the meadow is in the fourth through ninth blocks.

STEP 1C: SKETCHING

Lightly sketch the horizon line and focus on the big shapes like the mountains, vegetation and meadow. Refer to the sketch above for guidance.

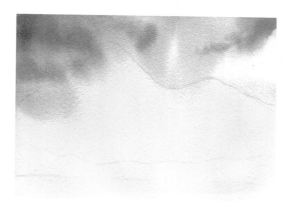

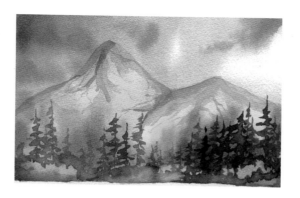

STEP 2: SKY

With your flat brush, pre-wet the sky and mountain area on your paper. When the paper reaches the soaked stage (page 72), apply coffee-like consistencies (page 20) of Ultramarine and Golden Deep separately. Paint Ultramarine on the upper part of the paper to suggest the sky and Golden Deep on the mountain area to serve as the underlying color. Let it dry.

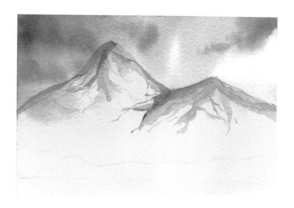

STEP 3: MOUNTAIN

In order to suggest snow on the mountain, you need to use a contrasting color paired with a darker tone. Paint shadows with tea-like (page 20) and coffee-like consistencies of Ultramarine on the dry paper. Be careful not to intrude into the lighter shadow areas. Let it dry.

STEP 4: PINE TREES

Prepare cream-like (page 20) and coffee-like consistencies of Sap Green and a milk-like consistency (page 20) of Golden Deep.

Re-wet the sky and mountain area, and add a coffee-like consistency of Sap Green at the foot of the mountain. Then, add some Golden Deep to make it more interesting. Tilt the paper for a few seconds and allow gravity to gently spread the colors. Let them be a soft background to the trees, which you will paint next after the paper has dried.

Once the paper is dry, load your size 8 round brush with a coffee-like consistency of Sap Green and paint pine trees of different sizes.

Rinse your brush and load it with a cream-like consistency of Sap Green. Paint pine trees in random areas. I was not very particular about the placement of mine because I just wanted to achieve a sense of depth by playing with color values. That is why we are using different consistencies of Sap Green.

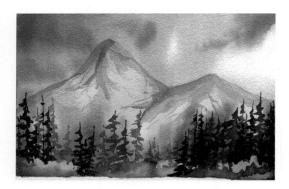

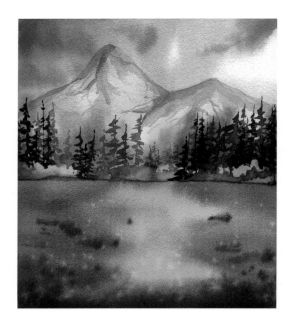

STEP 5A: LIGHT ON THE MEADOW

Using a flat brush, wet the lower part of the horizon. Load your size 8 round brush with a coffee-like consistency of Golden Deep and apply it to the lower part of the horizon while the paper is in the soaked stage.

STEP 5B: MEADOW

While the paper is still soaked, load the same brush with a milk-like consistency of Sap Green and apply it to the lower part of the horizon as well, avoiding the middle part. Let Golden Deep and Sap Green blend.

STEP 5C: DARKER GRASS

When the paper has reached the moist stage (page 72), apply a milk-like consistency of Sap Green in random areas to suggest shadows. Do it quickly and let it dry.

5A 5B

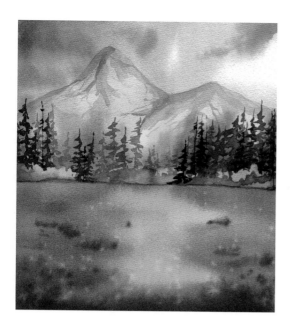

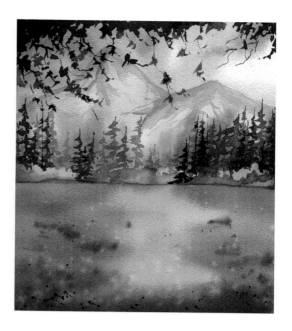

STEP 5D: TEXTURE

Load your size 4 or 6 round brush with just clear water. Make sure that the brush is not too full of water or it will explode on the surface of the wet paper. Carefully tap the brush to splatter some water on random areas of the meadow to create blooms. You may recall using this technique in the Sun Glitter project on page 118. Let it dry.

STEP 6: FOLIAGE

Using your size 8 round brush and a milk-like consistency of Sap Green, paint the foliage on the upper part of the paper. As in the Meadow project (page 101), use the tip of your brush to make gestural marks that suggest foliage. To prevent your strokes from looking mechanical, use different amounts of pressure. To add volume in the foliage, add paint to your brush until it becomes cream-like in consistency, and add another layer of foliage in random areas. Let it dry.

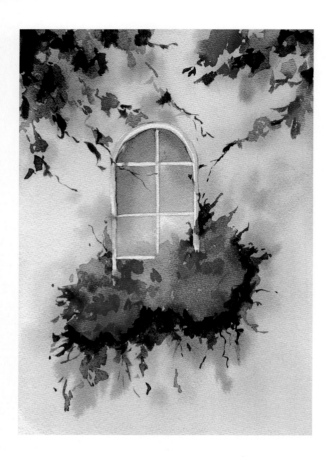

SONGS FROM THE WINDOW

One thing that the COVID-19 pandemic demonstrated is that we are all a community and we are all equal. When Italy was one of the worst-affected countries, people sang and danced with each other through their windows. In Singapore, thousands simultaneously sang the popular song "Home" through their windows to thank frontline workers. During the lockdown, we supported each other through our windows. It was beautiful to find silver linings even in the deepest, darkest times, and it made me feel less scared.

MATERIALS

Masking or painter's tape

140lb (300gsm), 100% cotton rag, cold-pressed watercolor paper

Painting board

Pencil and eraser

Synthetic round brush

Masking fluid

Flat brush (page 12)

Round brush, size 8 (page 12)

COLOR PALETTE

Aureolin, Golden Deep, Quinacridone Rose, Sap Green and Indigo

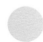

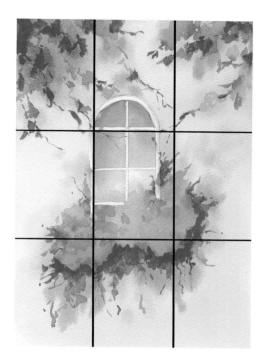

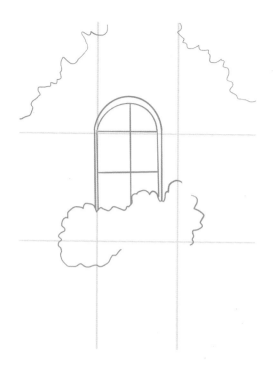

STEP 1A: PREPARATION

Prepare the materials on your painting table, including the paints you are going to use for the wash in Step 2. You will be using the wet-on-wet technique (see page 72), so preparing the paints in advance will help you transition smoothly between colors before your paper has a chance to dry.

Using masking or painter's tape, secure your sheet of watercolor paper to a board. This is to prevent the paper from buckling or curling. You can skip this step if you're using a block of watercolor paper.

STEP 1B: SCENE STUDY

Use the grid overlay to conduct a scene study of the example painting. Identify the key elements in this project. There are flowers and foliage in most of the blocks. The window is in the second and fifth.

STEP 1C: SKETCHING

Use the guide above to lightly sketch the window and other elements.

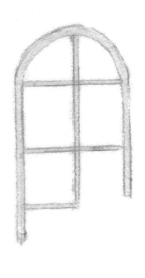

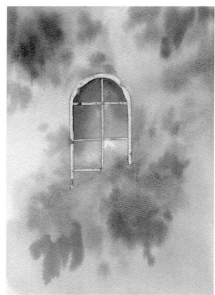

STEP 1D: MASKING FLUID

Apply masking fluid to the frame around the window and the divider inside the frame. Let it dry completely. I use a hair dryer sometimes to dry the paint and masking fluid faster.

STEP 2: BACKGROUND

Prepare milk-like consistencies (page 20) of Aureolin, Golden Deep, Quinacridone Rose, Sap Green and Indigo.

Pre-wet the surface of the paper evenly, then wait until the paper reaches the moist stage (page 72). Remember that when the paper is moist, you'll have less time to work than when the paper is soaked. Don't overthink your strokes—just apply the paint and move on. Use the sketch as a guide for where to apply the paints.

First, apply Golden Deep, avoiding areas where flowers and foliage will be. Then apply Aureolin and Quinacridone Rose separately on the window box and other random areas you want to suggest flowers. Let the colors blend on the paper and refrain from mixing them with your brush.

Apply the Sap Green carefully so it won't produce mud. Lastly, apply Indigo on the window, saving some white to suggest light striking the window. Alternatively, wait for the paper to reach the damp stage (page 72) and use the lifting and tissue blotting technique (page 111) to regain white spaces on the paper. Let it dry.

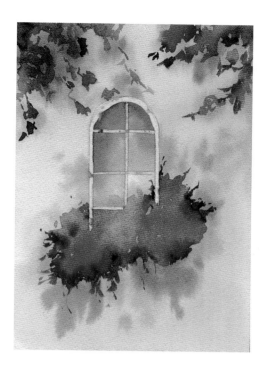

STEP 3: LAYER AND DETAILS

Add volume by painting on top of the flowers and foliage with your round brush loaded with milk-like consistencies of Quinacridone Rose and Sap Green separately. Paint the general shape of the foliage and not the realistic details. Keep it loose with erratic brush strokes with different amounts of pressure.

Carefully peel off the masking fluid with your fingers or an eraser. Then glaze the window frame with a milk-like consistency of Golden Deep. Once done, load your round brush with a cream-like blend (page 20) of Sap Green and a hint of Indigo. Add dark branches and foliage on the flower box and on the upper part of the page to create contrast.

Let it dry.

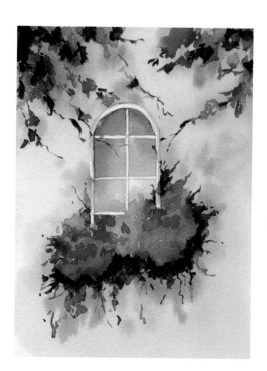

Acknowledgments

This book would not have been possible without the support and nurturing of Madeline Greenhalgh of Page Street and the rest of the Page Street family who kept me excited and thrilled throughout the entire process. With their expert guidance, this book was a joy to write.

I cannot begin to express my gratitude to my workshop students over the years; to my Instagram watercolor and creative community; to my mentor, Drew; to brands like Nevskaya Palitra, Silver Brush and Hahnemühle—thank you for your tremendous support and friendship! I'm deeply indebted to Nestee for proofreading and trying out the projects so I could improve my delivery, and to the TDP family—especially Shaezwan, Jing, Si Jing, Deanne and Zoe—for encouraging me to be creative from the beginning.

I would also like to thank my family and friends for being supportive and encouraging me in my creative journey, including Ah de, Leah, Meeya, Rei and Jham, my creative enablers. Special thanks to my best friends Kathrina, Patricia, Melo, Vince, Charm, Guiller, Jeremy and Portia for showering me with love, keeping me grounded and making sure I'm not stressed. To Lannah and Shay, may you grow up strong and kindhearted like your mom. I'd also like to extend my gratitude to Vee, Cris and Angel for being understanding and helpful during the writing process.

To everyone else I failed to mention, thank you very much!

May those who read this book find the same joy in watercolor painting that I have found over many years.

About the Author

Jovy Merryl is a watercolor artist, business owner, ambassador of White Nights of Nevskaya Palitra and one of the first artists in Asia to become a Certified Silver Brush Educator. She has collaborated with known brands like Legion, Hahnemühle, Escoda, M. Graham and QoR, to name a few. She is known on Instagram for her powerful watercolor paintings that evoke emotion.

Jovy enjoys teaching in-person workshops in Singapore and in the Philippines. She believes that art can always be learned, no matter what stage of life you are in, and she hopes that her artworks can connect her to more people and somehow give them a chance to let art change their lives too. Her passion for travel adds to her inspiration to paint more landscapes and bodies of water and to express and tell her story in every piece she creates.

Index